Politics by Other Means

Selected Criticism from Review 31

Politics by
Other Means

Selected Criticism from Review 31

Edited by

Houman Barekat and Alison Hugill

Winchester, UK
Washington, USA

First published by Zero Books, 2014
Zero Books is an imprint of John Hunt Publishing Ltd., Laurel House, Station Approach,
Alresford, Hants, SO24 9JH, UK
office1@jhpbooks.net
www.johnhuntpublishing.com
www.zero-books.net

For distributor details and how to order please visit the 'Ordering' section on our website.

Text copyright: Edited by Houman Barekat and Alison Hugill 2013

ISBN: 978 1 78279 123 2

A CIP catalogue record for this book is available from the British Library.

Design: Lee Nash

Printed and bound by CPI Group (UK) Ltd, Croydon, CR0 4YY

We operate a distinctive and ethical publishing philosophy in all
areas of our business, from our global network of authors to
production and worldwide distribution.

CONTENTS

Introduction:
Community as Communication

Alison Hugill & Houman Barekat

At a recent symposium at University College London to mark the launch of N + 1's anthology, *Say What You Mean*, editors from that publication and the London Review of Books discussed, among other things, the increasingly precarious position of the writer in contemporary culture. At the heart of the debate was the political economy of the transition to the digital era, which has been a source of so much uncertainty and ambivalence for those of us who are concerned with the future of publishing. It is a dilemma of critical significance to independent publishing in the 21st century: how to harness the democratising potential of the digital revolution while at the same time making ends meet in the real world of pounds and pence.

Though the general mood has been one of stagnation and despondency, there is plenty of evidence of dynamism too. As usual with all things Internet, the Americans were ahead of the curve: the excellent Los Angeles Review of Books, launched in 2011, has in a relatively short time established itself as one of the leading online literary publications; an ambitious, cosmopolitan gaggle of New York-based publications, chief among them the cultural magazine The New Inquiry, are also making their presence felt online. These projects have yet to solve the conundrum of sustainability - few, if any, are currently viable concerns in the business sense - but they are carving out a signif-icant space for themselves, and readers are responding in droves. So it was in a spirit of cautious optimism that Review 31 entered the fray in October 2011, with the aim of establishing itself as a British counterpart to these exciting Stateside initiatives.

The first year of Review 31's existence produced an array of

exceptional contributions from international scholars, journalists and writers. The highlights included in this volume reflect some of the most compelling critiques of recently-published titles in the realm of art, philosophy and cultural theory. Encompassing a broad sweep of subjects from modernism and literature through to the onset of the digital age, our art & culture coverage has very deliberately kept one foot in the sphere of politics at all times: many of the books chosen for review offer incisive criticism of orthodox economics, liberal democracy and labour conditions through their discussions of art, architecture and culture.

For example, Nina Power's review of E-flux journal's *Are You Working Too Much?* considers the implications of immaterial labour and precarity in the art world. Power situates her commentary in the context of the austerity measures and student revolt in the UK and provides, throughout, a Marxist critique of value. In a more politically subtle yet no less cogent instance, Luke White reviews a monograph of the modernist architect (and son of Sigmund) Ernst L. Freud. White questions the author's minimal interest in the class structures at work in Freud's practice. The subtitle of the book - *The Case of the Modern Bourgeois Home* - he argues, promises a deeper interrogation of the relationship between modernism and the bourgeois class that it ultimately fails to deliver.

If the future of print publishing looks pretty bleak, digital culture offers, in compensation, a potential for productive intellectual engagement that may yet eclipse the heyday of print. Far from killing literary culture, it will only invigorate it. As Maurice Blanchot has written, it is through reading that the 'illuminating violence of communication erupts.' An author's work – the book – is never complete. It is always an attempt at communication, failed or otherwise, that addresses itself to the reader. In their writings on community, Blanchot and his contemporaries Jean-Luc Nancy and Georges Bataille sketched out what they called 'literary communism,' in which the author and the readers

become intimately connected to the life of a work - not to its success as a completed work, but to what is incommunicable in it.

What is shared through reading is indispensable to this sense of community as communication. Literary criticism cannot be falsely portrayed as creating a harmonious and seamless dialogue between author and reader with regard to the meaning of a text. What it does do, however, is expose us to the instability of communication and thus to what we all share as humans. The reviews collected in this book are evidence, then, of a shared commitment to an intelligent, critical and broadly inclusive intellectual climate.

Acknowledgements

We would like to extend special thanks to everyone who has been involved in the production of Review 31 in its first two years: George Potts, Tom Cutterham, Luke Neima & Marc Farrant on the editorial side; Tim Coyle for designing our logo and posters; to all our contributors; and most of all to Theo Graham-Brown for his work in designing and maintaining the website.

An End In Themselves

Ian Birchall

McKenzie Wark, *The Beach Beneath the Street: The Everyday Life and Glorious Times of the Situationist International*
Verso, 208pp ISBN 978184467720 £14.99

Few left currents have been as adept at using capitalist marketing techniques as the Situationists, with their relentless self-promotion. They have succeeded in fooling a younger generation by retrospectively inserting themselves into a history to which they were at best marginal. Thus Jonathan Derbyshire (Guardian, 20 August 2011) assures us that they exerted 'the most profound influence on the French student movement in May 1968'. I was in Paris in the aftermath of the general strike, meeting and interviewing activists; nobody, absolutely nobody, mentioned the Situationists.

So McKenzie Wark's new book makes an interesting if contradictory contribution. Though highly favourable to the Situationists (so-called because they sought 'the production of new situations as an end in themselves'), he actually provides an honest account which helps to cut them down to size. He traces their intellectual trajectory from their origins in the Letterist International, and rather than focussing exclusively on the group's principal theorist, Guy Debord, he draws out the important contributions of artist Asger Jorn and novelist Alexander Trocchi, as well as more (relatively) obscure figures such as writer Isidore Isou and urbanist Constant Nieuwenhuys.

Wark locates Situationism within the intellectual context of its time, drawing interesting parallels with the thought of Henri Lefebvre and Derrida, and even Sartre and Raymond Williams. We learn of the Situationists' acute humour – such as the slogan

for dormitory suburbs around factories: 'Remember, you are sleeping for the boss', or Jorn's spoof kinship diagrams for imaginary tribes, which 'seem baffling at first, until the reader decodes the forest of symbols and realizes that anyone can fuck anyone'. But Wark also shows some of the low points, with Jorn's confused misunderstanding of Marx's value theory and a long summary of Michèle Bernstein's romantic novels, which I shall strenuously avoid reading.

He gives brief but often illuminating explanations of some of the key Situationist concepts: *dérive* (drifting, turbulent liquid movement), *détournement* (quoting in order to change and appropriate for different purposes) and *potlatch* (gift without expectation of reciprocation. Wark's highly laudable aim is not to give a purely historical account (though his book is carefully documented) but to seek in Situationism resources for rebels of the future, those seeking to 'leave the twenty-first century'. Unfortunately those resources are rather slender. Situationism was essentially an aesthetic movement. It came up against the discovery that in modern capitalism aesthetics and politics are inextricably linked; but the attempt to move into politics was derisory, and if it had been less irrelevant would have been catastrophic.

Take Debord's slogan 'Never work', which so appeals to Wark. It is a refreshing response to the tedious diatribes about 'hardworking families' with which the Cameron-Miliband duo belabour us. It may be a legitimate personal motto for an artist or a professional revolutionary. But for the rest of us it is a nonsense. No human society can exist without labour, and presumably Debord was quite happy that someone else's labour should produce his food and clothing. As for the Situationist hope that work was disappearing, it was based on a complete misreading. Anyone in work today can tell you that their job is harder and more time-consuming than it was thirty years ago.

Wark deals lightly with the Situationists' history of splits and

expulsions, which reads like a parody of the worst manifestations of the far left. But as Wark acutely notes, the big difference was that, while the Situationists were very hot on expulsions, they made little effort to recruit. Since they started with nine members, the results were foreseeable.

May 1968, the biggest general strike in human history, put would-be revolutionaries to the test. The Situationists failed miserably. They noted quite correctly that the working class was isolated in face of the state and the trade unions. But there is no evidence that they joined other revolutionaries at the factory gates, trying, despite their small numbers, to by-pass the conservative influence of the French Communist Party. Then, when the movement began to go down, the state banned a number of revolutionary organisations. The serious revolutionaries in France recognised that this was a gesture to the regime's conservative middle-class supporters; it meant a bit of harassment but was certainly not something on the scale of Chile 1973; they changed their names and reorganised themselves within a matter of days. The Situationists were not banned (doubtless nobody in the state security apparatus had even heard of them), but they fled to Brussels in any event.

Essentially the Situationists were comedians. Comedians have a valuable role to play, not only in amusing us, but in undermining some of the myths that bolster up the status quo. But to expect political guidance from them is like imagining Ernie Wise leading the October Revolution.

They Found Much to Like

Jeremy Spencer

Maclolm Turvey, *The Filming of Modern Life: European Avant-Garde Film of the 1920s*
MIT Press, 170pp ISBN 9780262015189 £20.95

In the 1920s, the embrace of film as a medium for visual art by members of the European avant-garde led to an outpouring of creativity. Artists such as Hans Richter, Fernand Léger, Francis Picabia, Salvidor Dalí and film-maker Dziga Vertov made the enduring and fascinating films explored in Malcolm Turvey's *The Filming of Modern Life*. Turvey explores how these films resisted and embraced, sometimes simultaneously, the specific concrete transformations wrought by modernity.

To explain what emerges as an ambivalent or contradictory relationship, Turvey discusses five films made in France and the Soviet Union, which although stylistically and thematically dissimilar, are fascinated with and seek to evoke the lived experience of modernity: the abstract or Dada films, *Rhythm 21* (Hans Richter, 1921) and *Entr' acte* (Francis Picabia and René Clair, 1924); *Ballet mécanique* (Fernand Léger and Dudley Murphy, 1924), an expression of 'pure cinema'; the Surrealist *Un chien Andalou* (Salvidor Dalí and Luis Buñuel, 1929); and *Man with a Movie Camera, Camera* (Dziga Vertov, 1929), a 'city symphony'. For Turvey, these films demonstrate a more nuanced and complex response to modernity, 'a more tangled stance' to the experience of modern life, than has been previously critically recognised.

Turvey believes there has been a failure to 'recognise the complexity of the avant-garde's relationship to modernisation'; he challenges the argument, which he associates with Theodor

Adorno and Peter Bürger among others, that the avant-garde of the 1920s opposed and desired to transform not just aesthetic or cultural but 'bourgeois modernity', that it wanted to change not only artistic conventions but life as a whole. Turvey comments that the critique of bourgeois modernity originating with Marxism and Romanticism is 'hypocritical and inaccurate' but according to the 'standard story' it is this critique that motivated the avant-garde's 'desire for radical social and artistic change'. Turvey, however, is interested in the *ambivalence* shared by avant-garde artists to bourgeois modernity; they were equally attracted and repulsed by it.

In the chapter on Richter's *Rhythm 21*, Turvey argues that Richter sought to ameliorate the 'worst excesses' of modern life predicated on rationality and calculation, through principles of unreason and the unconscious. He argues that *Ballet mécanique* does not unequivocally embrace mechanisation but 'offers an antidote' to modernity in the form of a classical ideal of beauty. In a similar way, Turvey challenges the view that Vertov unambiguously supported machinism and that the enthusiasm for the machine in the Soviet Union is the best way to explain *Man with a Movie Camera*, seeing instead the 'complex living organism' as a more important reference.

The critique of the bourgeoisie or bourgeois modernity originated in the Romantic reaction to the Enlightenment and the industrial revolution, which Turvey associates with Friedrich Schiller and, more contemporaneously, with art historian TJ Clark's discussion of modernity. "Bourgeois" can signify a set of values, primarily the bourgeoisie's 'dedication to improving one's material well-being using instrumental reason', which although supposedly rejected by avant-garde artists, are associated with individual freedom and self-responsibility and, therefore, dignity. The freedom to pursue material wants can be seen as a unifying and civilising force. Turvey sees in industrial capitalism – one of the possible meanings of "bourgeois

modernity" – the means 'to lift ... people en masse out of degrading poverty and cushion them from the ravages of nature'; his contemporary examples are China and India.

Turvey is also critical of 'the modernity thesis' – 'a major explanatory paradigm in film studies' – a thesis on the relationship of cinema and modernity inspired by the writings of Walter Benjamin and Siegfried Kracauer. Benjamin saw a new type or mode of perception emerging within modernity, which he dates to the mid-19th century, characterised above all by *distraction*, by sensory and perceptual overload as a symptom of living in cities. The argument is that modernity caused a funda-mental change in perception. This 'distracted mode of perception' is perpetuated in modern visual culture, including cinema. However, Turvey doubts that human, primarily visual perception could evolve so quickly; he questions the way Benjamin uses "distraction" to describe the experience of watching a film and the idea that films are distracting; he argues that an audience's experience of film is not like the distracted perceptual experience of everyday life in the modern city 'because their images and sounds are presented sequentially, not simultaneously'; although films have tried to *approximate* that experience, 'the modernity thesis' does not characterise cinema more generally.

The main argument of the book is that avant-garde artists and film-makers of the 1920s 'found much to like in modern life'; through detailed analysis of the five films and the aesthetic arguments that surrounded them, Turvey challenges the view that the avant-garde were 'implacably opposed' to and rejected bourgeois modernity in the name of post-capitalist or socialist society. The significance of these films is in they way they suggest, and are symptoms of, the conflict in modernity - the desire for the benefits that modernisation can bring and the disgust at 'the inequalities it seems incapable of eradicating'.

Innovations in Exile

Theo Reeves-Evison

Gregory Sholette, *Dark Matter: Art and Politics in the Age of Enterprise Culture*
Pluto Press, 256pp ISBN 9780745327525 £17.99

For 2011's annual charity gala at the Los Angeles Museum of Contemporary art, Maria Abramovic hired six female performers to re-enact her signature work *Nude with Skeleton* (2002). In contrast to the original, filmed performance, in which Abramovic lies under a replica skeleton made to the dimensions of her body, for the gala event performers were hired as decorative table centrepieces under strict instructions to 'remain in the performative' even if that meant enduring physical or verbal abuse. For many, the most troublesome aspect of the event was not the price that tickets fetched (as much as $100,000 each), or even the museum's insensitivity to shifts in context and meaning, but that 800 women, mostly artists, put themselves up for audition.

The configurations of value and cultural capital that make possible such self-willed exploitation is one of the principal targets of Gregory Sholette's *Dark Matter*. Using a raft of Marxist and post-structuralist theoretical resources, Sholette unpacks the issues embedded in his chosen case studies, ultimately asking what would happen if the bottom of the pyramid were to be removed: if hobbyists stopped buying art-supplies, amateurs stopped taking classes, and if the tens of thousands of art-students graduating each year started to set up alternative systems of symbolic exchange, instead of propping up the star system that guarantees only a select handful success.

The idea of dark matter is variously defined in the context of creative production as an 'obscure mass of failed artists', 'an

7

unseen accretion of creativity', and a 'mark or bruise within the body of high art.' Despite the obvious, and in some ways constitutive fuzziness of the term, Sholette mobilizes it to probe the political economy of contemporary art and enterprise culture in general. For readers familiar with the work of Alain Badiou and Jacques Rancière the idea of dark matter as an 'internal exile', or 'a part with no part' declaring itself to be visible will not seem like much of a theoretical innovation. In fact, it could be argued that the apparent influence of these authors on Sholette's argument is the subject of a foreclosure in its own right. Concepts that have a properly ontological grounding in the work of Badiou and others are either assumed as axiomatic or reduced to motifs. The pay-off for such an approach is that the artworks discussed are given more granular attention, and analyses are expanded to take in a broader sweep of relevant philosophical and social critique.

On a less abstract basis, *Dark Matter* is also a book about innovation itself and its relation to adaptability. For Sholette - as for many of the Marxist scholars that inspire his approach - it is not simply that the majority of 'emerging' artists are willing to work for free, happy to make do without employment rights, pensions, or a guaranteed income; often working second or third jobs to support their practices, but that this paradigm is increasingly becoming the norm in other spheres of economic activity as well. The figure of an artist as a flexible, creative entrepreneur; self-promotional and at ease with instability, has become a model for employees in general under what Boltanski and Chiapello call the 'new spirit of capitalism' in their book of the same name. The freedom to transform, to re-train, to remain in perpetual motion, today takes the form of an imperative. For the author of *Dark Matter*, the guiding question is how to make critical art in a world that welcomes it with open arms.

In search of answers, Sholette assumes the role of an archaeologist in order to unearth artworks and instances of informal

creativity that he sees as antagonistic to the forces that seek to co-opt them. The works discussed range from an impromptu collage of detritus pieced together by a group of factory workers in Pennsylvania to sophisticated forms of tactical media and culture jamming that mimic existing organizational structures in order to disrupt and infiltrate them. Uniting these two poles is the idea that it is still possible to create something outside of the symbolic hierarchies of the official art-world, a construct that the author eyes with justified suspicion. Moving chapter by chapter through various case studies, Sholette lingers on art-works made collaboratively by groups such as Temporary Services and The Critical Art Ensemble, reserving praise for projects that seem to have the capacity to disrupt while disengaging with the forces that would seek to recuperate them.

Structured more or less in a chronological fashion, *Dark Matter* opens with a lengthy discussion of Political Art Documentation/Distribution (PAD/D), a project that archived, and – as the name suggests – distributed politically engaged artworks and ephemera between 1980 and 1989. In this chapter, and at later points in the book, this archive is drawn upon as a means of reactivating historical sediment and allowing its material to disturb the present. Other case studies allow Sholette to engage with a range of issues from Major Giuliani's 'clean sweep' of New York City in the 90s to the various efforts by groups like the Art Workers Coalition and the Artist Pension Trust to secure employment rights for artists. Bringing his analysis up to the present day, Sholette ends with an appraisal of the now widespread turn towards tactical media, pedagogical forms of intervention, and the mock-institutionalism of groups such as The Yes Men, the Bureau of Inverse Technology and the Critical Art Ensemble.

The fact that Sholette devotes two lengthy chapters to artist groups of which he himself was a part may strike some readers as rather opportunistic for a book devoted to the subject of enter-

prise culture. Is Sholette really landing a punch on the body of high art or is he trying to make sure his name gets into its history books? A more generous way to look at this would be to consider *Dark Matter* as a textual extension of these projects, or as a kind of self-appraisal, no less committed to the activist ideals than the work it draws upon. In any case, this is not a book that could have been written by an outside observer or by the recipient of a three-year research grant. Within its pages there lie insights that speak of a lived engagement with political art stretching over thirty years. Sholette describes his book as 'an attempt to infect the "lawfully" embodied systems of exclusion and visibility'. As well as achieving a great many of its aims, the most infectious aspect of *Dark Matter* proves to be its author's passion and commitment to the issues at stake.

How to Find a Better Life?

Nina Power

Julieta Aranda et al. (eds.), *Are You Working Too Much? Post-Fordism, Precarity, and the Labor of Art*
Sternberg Press, 216pp ISBN 9781934105313 £10.95

The notes at the back of this latest e-flux collection state that one group of contributors, the Precarious Workers Brigade, 'have a policy of including information on the context in which their work appears.' To this end, they detail the dates when the piece was written (March - April 2011), the number of people involved in writing it (nine), that their text is also available online for free and is licenced under a Creative Commons licence, how they spent the $750 they were paid for the article ('collective investment') and the fact that e-flux journal employed two interns to work on the journal the article appeared in.

How much were these interns paid? $0 an hour. This single line sums it all up: the 'work' of the art world, and the increasing tendency of all work, is predicated on the fact that those at the bottom (and increasingly the middle) will do everything for nothing. But why, ask the editors, 'should so many talented and hyper-qualified artists submit themselves willingly to a field of work ... that offers so little in return for such a huge amount of unremunerated labor?' Why indeed? The editors talk of the combination of structural exploitation and self-exploitation that characterises the 'pseudo-professionalism' of work in the art world (and we could include in this description not only artists, but curators, art writers, and all those at the less glamorous end of the gallery/museum/art fair spectrum). This unhappy situation in the art world (and the rest of the world) is the crux of the collection at hand.

The flip-side of the structural inequality of the art world, a curious microcosm of the global financial system that massively overlaps with it at the level of speculation and the increasing abstraction of 'value' that art currently symbolises, is the kind of work – constant, frenetic, networked, endless, overlapping, highly libidinally-charged but exhausting - that characterises freelance art world labour. A poster on the Precarious Workers Brigade's website asks 'Do you freelance but don't feel free?' and 'Are you anxious during the day and sleepless at night?' Identifying the material conditions whereby work and its unpaidness are interlinked is the task of many of the essays here. Rather than posing this question in the usual way – namely, how does art 'deal with' politics? Can artwork 'be' political? – Hito Steyerl discusses 'the politics of the field of art as a place of work'. Contemporary art, she argues, is 'squarely placed in the neoliberal thick of things'. A 'brand name without a brand', it 'lends primordial accumulation a whiff of post-conceptual razzmatazz' and is in practice, the answer to the question 'How can capitalism be made more beautiful?' So far: recognisable, acutely described and utterly depressing.

Returning to an old Soviet concept of 'strike' or 'shock' work, Steyerl recognises that the contemporary production of art operates on precisely these lines, albeit less with painting, welding, and moulding than with 'ripping, chatting and posing', operating as 'affective labour at insane speeds, enthusiastic, hyperactive, and deeply compromised.' Steyerl speculates that apart from domestic and care work, art work, characterised in this accelerated way, is the industry premised on the 'most unpaid labour around'. It is also one of the hardest kinds of labour to organise, since it rarely recognises the conditions of its own production, even while it 'routinely packages injustice and destitution'. Steyerl argues that 'opportunism and competition' are not affects that operate at the margins of art labour, but are structural features of its very ability to run (just think about the

ethical and subjective dilemmas of applying for funding, and the logistical difficulties of operating as an art collective, or without 'contacts').

As a way of moving forward, Steyerl suggests a return to institutional critique, but on a massively expanded scale that would include critique of sponsorship by banks, arms traders, funding patterns and financial sources, laid bare and open for all to see. If Charles Saatchi, of all people, now finds himself alienated from art collecting because it has become 'the sport of the Eurotrashy, Hedge-fundy, Hamptonites; of trendy oligarchs and oiligarchs; and of art dealers with masturbatory levels of self-regard' (Guardian - Comment is Free, 2 December 2011), then something in the art world really has tilted into absurdity (though of course Saatchi's moralistic ego-centric vision is not a stand-in for a serious mapping of the relations of capital and art.) But Steyerl is no moralist and she is not interested in 'clean-hands' politics either, as if that would be remotely possible. It is, as she says, 'at best illusory, at worst just another selling-point'. She suggests that what is most alien to the contemporary art world (though less and less to forms of contemporary politics, perhaps) is 'solidarity'.

Solidarity in the art world, with all of its contradictions and impossibilities, is best exemplified in the document by the afore-mentioned Precarious Workers Brigade, whose account of 'a week that changed everything' analyses events in London during November 24 – December 9th 2010, a period of time that now seems both incredibly distant and highly proximate, inasmuch as the student and anti-cuts protests, as well as their violent police repression, have come to characterise much of the political scene since that time. The strength of the Precarious Workers' reflec-tions, particularly compared to some of the more idealist musings on art, work and labour contained in the rest of the collection, lies in their honesty regarding the manifest difficulties they encounter, both conceptually and practically, as well as their

definitive calls for 'the articulation of a cultural and political commons', for 'free education for all' and for cultural assets 'to be managed through democratic processes'. Their document captures the excitement and turmoil of that week: when they write that 'regimes of spectatorship, observation, and aesthetic judgement ... that felt so impenetrable before, suddenly seem anachronistic in the context here and now,' I know exactly what they mean. The questions that emerged around this time are well-summarised in the questions the group proposes to take forward, among them: 'How do we maintain the momentum of event-togetherness-excitement in all of our practices?' and: 'How do we begin to set up the world we want to be in?'

The complex positivity of the Precarious Workers Brigade's diagnoses finds its dark mirror in Franco Berardi (Bifo)'s reflections on 'semiocapital' in "Cognitarian Subjectivation". Here Bifo describes the 'epidemic of panic and depression' that is 'spreading throughout the circuits of the social brain', where neuro-physical energies are put to work and the emotional energy of the 'cognitive class' (or 'info-producers') is exploited, rendering these workers desensitised, precarious and lacking pleasure. While it is always dangerous to generalise about the experience of work, or to privilege one type of worker over another – and as Keti Chukhrov points out in her essay on immaterial labour and post-Soviet labour, 'the central contradiction of the theory of immaterial labour consists in the fact that the zones of oppression, physical exploitation, and material labour often lie beyond its interpretation of the commons' – Bifo is surely correct when he points out that attacks on the education system are part and parcel of a war on cognitive labour ('The university system across Europe is based on a huge amount of precarious, underpaid, or unpaid labour') and that 'the economy has achieved the status of a universal language'.

It is not enough to understand that immaterial labour and precarity are making us sick: Bifo suggests we need to find an

'erotic social body of the general intellect' to get any sort of grip on the ways in which immaterial and cognitive work is sliding away from us and being ever-devalued. The art world provides a peculiarly privileged vantage point for surveying the wreckage of post-Fordism (or whatever we might call it): but solutions are few and far between. Questions, however, are better than nothing, and there are more than enough to go round here. As Liam Gillick inquires in his essay, "The Good of Work": 'How to find a better life in all of this?'

A Babble of Allusions

Rosa Ainley

Sarah Edwards & Jonathan Charley (eds.), *Writing the Modern City: Literature, Architecture, Modernity*
Routledge, 240pp ISBN 9780415591515 £29.99

Watching Steve McQueen's *Shame* recently I was struck by the role Manhattan played in the film: far more than a set for the action, the spaces of the city are shot in such a way to make possible the narrative of extreme disassociation. Emerging from the clinical anonymity of his apartment where human contact comes via webcam porn subscriptions, the protagonist watches a couple having sex in a glass-sided skyscraper, the woman flattened against the window/wall, facing outwards to the vertiginous view. In this collection of essays the point is often and variously made that certain narratives could only be created once spaces for them existed too. It's a symbiotic process, one where narratives and space are mutually defining and influencing character, histories and movements within the urban.

The intention of the editors is to explore new forms of narrative that represented 20th century cultural modernity, a modernity characterised by developments in communications and speed and in new technologies and disciplines that made new forms possible and imaginable. In his introduction to the collection Jonathan Charley sets out how both architects and novelists (not to mention writers of short stories, creative non-fictions, among others) are 'jugglers of space, time and narrative'. By contrast with the architect, the writer is, he says, 'unencumbered by the practical'. If only that were true. But while a writer's work might outlive a building, the writer – although freed from the constraint of having to make a structure that will literally

stand up – has to create work that will withstand scrutiny. I'm in agreement with Charley that the disjuncture between how writer and architect choose to represent the modern city is one of the most interesting features of the debate on architecture, literature and modernity. The similarities are no less absorbing. Both writing and architecture start by imagining the unimaginable, giving it form, pinning it down – or a version of it – at least long enough to draw it or write it.

Lefebvre's notion of the impossibility of reconciling the dichotomy of the imagined and the everyday, cited by Sarah Edwards in her introductory essay for the third section of the collection, is fertile territory for both writer and architect (and to this we might add that of public and private. Further, Lefebvre's concept of the inseparability of space and social relations makes clear the pull of the urban as subject and form for writer and architect. Here is the underpinning for this book, and the role that architecture and spatial narratives have in the construction of social, political and personal histories, how narratives shape the meanings of buildings and how these overlap and re-inform each other. In 2008, the year of the Architexture Conference that 'led to the commencement of this book', the embedding of creative writing as an academic discipline was well underway; by 2012, this proliferation within and beyond the academy has led inexorably to the process of specialisation, one indication of which is a number of such courses focusing on space, place and environment. This is an ideal foundation text, and one that operates too as a springboard in its breadth as well as its finely detailed analyses.

It is Inga Bryden who invokes the idea of 'babble' in her piece, in relation to the 'fragmented polyvalent nature of the city' in the work of Maria Crossan, Ian Sinclair and Jon McGregor, which I have (mis)appropriated here for the title. Its sense of a joyful, messy multiplicity disallowing sequential, linear narrative, suggesting the audible and atmospheric, suggests a more fitting

description for the collection than the more often invoked and, to my mind, sombre tone of the palimpsest, its layers awaiting excavation. The hectic babble of conference may be tamed here but the book, like its antecedent, delivered not only references to seek out, readings to ponder, a new word (ipseity) but also a new phrase. Patrick Wright's wonderful 'machines for harvesting subsidies' deserves to be as widely quoted as Corbusier's 'machines for living', which it appropriates – referring to the financial bait behind the massive housing blocks erected in many British cities in the 1950s and 60s. Another phrase resonates particularly for me from Bryden's piece, which examines the links between the roles of writer and architect in realisation of narrative and form: how writers 'make their streets tell'. She brings a welcome focus on the architectonics of writing: the structures, the processes and the materials becoming part of the subject.

Inevitably in a collection of this scope some areas suffer. The debate on third-wave and post-feminist stances on sex and porn need more space than allowed here, as do the admittedly well trodden but over-compressed considerations of Situationism and psychogeography. Psychoanalysis and postmodernism are conspicuously absent, as is the overdue recognition for interdisciplinary work. One small production note: the image reproduction is quite grey and flat, undermining the vibrancy of the images and their excellent captioning, which almost gives the feel of an autonomous, interconnected piece.

Each of the three parts of the anthology is titled by three words: memory nation identity; movement culture genre; narrative form space. I found it worked better – more instructive, less directive – to read the section introductions after the essays. Again these groupings are buzzing with allusion and some are more productive than others. There is an eloquence in the adjacency of Mark Mukherjee Campbell's and Victoria Rosner's essays on the impact of design on colonial identity politics in,

respectively, India and Rhodesia, as was, through the work of Tagore and Lessing. Here again the point is stark that works about new spaces can only be made when forms of urbanisation exist for them be located in, or imagined in contrast. Just as progressive urbanists and writers have disrupted the simplistically easy fit of public housing with crime scenario, so idealised forms of urban space to plan out disorder, social and individual are exposed. Interestingly this is represented here by both science fiction (well represented by David Fortin's piece on Philip K Dick) and, more unusually, a non-literary text on town planning, the latter in Brian Ward's fascinating essay 'Poets, tramps and a town planning', which introduces planner Raymond Unwin's text alongside the writings of Walt Whitman and Edward Carpenter.

Last year's clearance of Dale Farm in Basildon was reminiscent of the razing of the traveller encampment in David Peace's quartet to allow redevelopment of the site, books heaving with 'the "architectural crimes" of corrupt and inequitable urban development schemes', where urban spaces are not backdrops for crime narratives but objects of crime. Peter Clandfield quotes a developer trailing a future of '[m]assive cultural initiatives making the arts accessible for all', writing on Martyn Waite's *The White Room*, likely to be another example of potential social benefit deformed by more urgent agendas of 'chronotopic capitalism' as Charley might put it. And thoughts turn to a new strand of regeneration fiction, along with theorising of these new typologies of space, featuring as sites and characters the Baltic, Turner Contemporary and the Olympic Village.

The Power of Culture

Phil Jourdan

Carl Freedman, *The Age of Nixon: A Study in Cultural Power*
Zero, 286pp ISBN 9781846949432 £14.99

We might be forgiven for assuming that the title of Carl Freedman's new book sounds rather ambitious for a work of just over 280 pages. However, *The Age of Nixon* is by no means a political biography in the normal sense. In part, this is an examination of Nixon the man, certainly, but it is also a study of the man as a player in American culture: how, for instance, he used cultural prejudices to his advantage at various points in his career. More broadly, *The Age of Nixon* explores the idea of 'cultural power' in itself: and it happens that Nixon, a complicated president and a most fascinating figure, provides a wonderful point from which to begin that exploration.

The content of any given 'culture' is hardly reducible to a few descriptive chapters in a book of political or cultural criticism, and Freedman's choice of Nixon as a point of focus is wise. It enables him to begin, however modestly, to conceptualise 'cultural power' in relation to a precise and well-documented, heavily-researched background. It also lets him extrapolate from his observations on Nixon's career a series of more general features of 'cultural power'. These are not exactly controversial; in fact, they are presented so digestibly that their usefulness at first seems limited. As the argument progresses, however, Freedman's initially vague definitions become more focussed, and commensurately more convincing and helpful.

After a biographical introduction to Nixon's career and a more theoretical chapter on the idea of 'cultural power' — as Freedman concedes, it's 'not a familiar phrase' — *The Age of Nixon* consists

mainly of short analyses of a few of the ways in which American cultural quirks helped or hindered Nixon's political life. Freedman uses the Nietzschean idea of *ressentiment* to make new sense of Nixon's 'Checkers' speech of 1952. The Marxian elaboration of the role played by the 'petty bourgeoisie' and the Freudian concept of the anal-erotic character also come into play. An entire chapter deals with Nixon's difficult relation to the Jews and other Others. And so forth.

These interpretations are never final, and neither are they even the 'point' of the book in themselves. The point, finally, seems to be to bring readers to an understanding of how culture *does* hold power, static as it can first appear. 'Cultural power' is of course related to, but distinct from, ideology: Freedman uses the example of flag-burning to bring to attention the nature of this kind of power: 'Burning a copy of the American flag that you yourself own is, for example, very obviously an act protected by the free-speech clause of the First Amendment to the Constitution ... But the act is so culturally repugnant to so many Americans that the Constitutional point usually counts for little in the public controversies on the matter that flare up from time to time.' This is cultural power: these deep-rooted and 'obvious' no-nos and of-courses that, for instance, make political change slower than many of us would like it to be.

Freedman's writing is exemplary in its directness. *The Age of Nixon* is not intended only for academics, and I would suggest that its impact will be felt more deeply in non-specialised audiences. Freedman's touch is so light that even those who are unfamiliar with - or wary of - Marx, Freud, Nietzsche are likely to be swayed by the way their work is appropriated here, with a friendly, non-condescending pedagogical clarity. Freedman's arguments might not amaze those who already take for granted the pervasiveness of 'banal' ideological factors in the determination of politics; but the book succeeds precisely because it reminds us that culture is *not* neutral, and that Nixon was not

just a fluke but a once-important player in a big game - a game far bigger than politics, and more complicated than pop psychology suggests. This is a work worth reading for the insight it gives into Nixon as a cultural icon, as a politician, and as a man of his time.

Clearer, and Clearer, and Clearer Still

Jeremy Spencer

Martin Gayford, *A Bigger Message: Conversations with David Hockney*
Thames & Hudson, 248pp ISBN 9780500238875 £18.95

The art critic Martin Gayford's book about David Hockney is a record of their conversations over ten years that expose Hockney's obsessions and preoccupations as an artist. The text isn't simply a straight transcription of their talks, whether in person or by telephone or email, and their exchanges, which reveal Hockney's thoughts on art and aesthetics, are not ordered chronologically; the text is an 'arrangement' of different 'layers' and Gayford contextualises their conversations with biographical and art historical essays. In these essays, Hockney's relation to the history of art comes across vividly. Gayford evokes the artists and artistic traditions, of landscape painting or the application of technology to make pictures, which are in different ways antecedents to Hockney's present concerns or can illuminate his trajectory as an artist.

Hockney has painted East Yorkshire landscapes since the later 1990s and those paintings that express his relationship with the sight of nature are an significant theme of the book. Gayford compares Hockney's love for 'the infinite variety of nature', the 'real subject' of his painting, hawthorn blossom in late May and early June, 'an exhibition of trees', with that of nineteenth century landscape painters, John Constable, Van Gogh, and Claude Monet. Trees, Hockney remarks that they have 'become friends', recur in his more recent painting. He was captivated by the 'constant change' and variation in light, the changing seasons, dramatic and pronounced, he discovered in Yorkshire,

in the seaside resort of Bridlington where he now lives and where can paint relatively undisturbed; Hockney says to Gayford that he 'wanted to paint the whole year'.

The book turns persistently to Hockney's undiminished fascination with pictures and picturing; Hockney talks about 'a deep, deep desire to depict' in human beings and he reflects upon the pleasure depictions impart, how we find pictures attractive; artist and critic agree that drawing is a primordial activity, innate, and human. They talk about the act of seeing, Hockney describing his 'intense pleasure from looking', his belief that through depiction we look at 'things we might not otherwise see'. Gayford describes Hockney searching for ways to depict the world differently to the way the camera lens sees it; although 'thinking about what is wrong' with photography, Hockney has always involved himself with it, 'participated in it', 'observed' it, using photographs and lenses to make his paintings. One thing that Hockney believes wrong with photography is that it can only show surfaces; his recent paintings, like his 'enormous' *Bigger Trees Near Water* of 2007, painted entirely out of doors, depict infinite and engulfing spaces. Although he acknowledges that photography and painting are inseparable, Hockney compares the academic painting of Ernest Meissonier and Willian-Adolphe Bouguereau, which are too photographic, to 'the more human vision of the world' of Cézanne and Van Gogh. Despite its attraction to us, Hockney suggests that photography has damaged rather than heightened our perception of the world, partly because we tend to confuse the photograph with reality and assume it as the 'ultimate reality', that it 'catches reality' when it fact it has made the world 'look very, very dull'. Reflecting on the differences between painting and 'the optical projection of nature', Hockney disputes the assumed reality of photographs, describing them as more like staged scenes. We don't really mind if a painted scene is composed or fake, he comments; the medium of painting allows an artist to do something that photography does not.

Hockney is enthusiastic in his embracing of new technologies of image production and dissemination. The relationship of art to technology has long been a quality of his work; he had made use of unusual mediums such as the photocopier and fax machine in the 1980s, working with their limitations. More recently, Hockney has drawn using an iPhone app, emailing the drawings of familiar and natural objects to his friends. It has influenced the way Hockney draws – 'it makes you bold', he remarks. His 'technological romance' continues with the iPad, drawing on its larger screen with thumb, fingers and a stylus. He says to Gayford, 'I love it, I must admit … Picasso would have gone mad with this. I don't know an artist who wouldn't.' These new technologies have affected the things Hockney depicts; his subjects have become more domestic and intimate, his naked foot next to a slipper, his checked cloth cap. The spontaneity and informality of the iPad pictures, Gayford comments, results from Hockney having the tablet computer always close to hand; it replaces and is much easier to carry than paints, brushes, and sketchbook. In contextualising these miniature paintings Hockney makes with an iPhone and then an iPad, Gayford considers artists who also made images with light: Thomas Gainsborough, who in the 1780s painted landscapes on glass intended to be illuminated and viewed in a 'showbox'; and the Diorama of Louis Daguerre, exhibited in Paris in the early 19th century.

Hockney, then, deploys technology to produce 'bigger and more intense' depictions of the visible and natural world; cameras can help artists 'see more'; although Hockney often expresses an opposing view, saying that he only really started seeing the hedgerows around Bridlington when he'd drawn them - their technological reproduction wouldn't demand the same intensity of looking, a photograph wouldn't be as affecting. 'Drawing', he remarks, 'makes you see things clearer, and clearer, and clearer still'. But the apparent inconsistency, which

Gayford also comments on, isn't damaging. Hockney understands their connectedness, the function of photography as the tool for the draughtsman, and in its more impure forms as collage, its affinity to drawing. He also elides the differences, talking of his fascination with 'pictures' as such, however they are made. Hockney's comments on the place of drawing in art education were suggestive but too cursory. This is an enjoyable book, comprehensively illustrated, engaging in its insights into an artistic life.

The Neglected Modernist

Luke White

Volker M. Welter, *Ernst L. Freud, Architect: The Case of the Modern Bourgeois Home*
Berghahn, 214pp ISBN 9780857452337 £25.00

Histories of modern architecture tend to accord Ernst Freud (youngest son of Sigmund, and father in turn to celebrity sons Lucian and Clement) only a marginal place, in spite of the high profile of his practice in 1920s Berlin, and then in London, where he moved in 1933. At the core of Volker M Welter's excavation of this neglected figure, is an argument about the structural reasons for his marginalisation from such histories. These understand modernism's importance to lie in the 'radical' credentials of its alliance with a socio-political project that sought to destroy an outmoded bourgeois present to build instead a proletarian future. Such accounts focus on grand housing projects, experiments in communal living, or the ergonomic reorganisation of working-class apartments. Freud in contrast, was an architect concerned with well-heeled clients, and with the bourgeois domestic interior. The psychoanalytic metaphor that seems to underlie Welter's account (though he never quite states it quite explicitly) is that such middle-class modernism gets structurally relegated to architectural history's unconscious. His detailed examination of Ernst Freud – a form of discursive therapy – sets out to recover these repressed contents.

Freud's work – that of a 'moderate' modernist, however oxymoronic the phrase may seem – does not orient itself around a modernity to come. Instead, his interiors served to facilitate and affirm an already-achieved modernity that the early 20th century bourgeoisie enjoyed. Such bourgeois life neither

involved the cluttered, dusty spaces that Walter Benjamin famously discusses; nor, however, did it involve substituting these for the hard, bright, unwelcoming surfaces Benjamin associated with modernism. Freud's architecture served the purposes of the early-20th-century middle classes' demands for comfort and convenience, their social and familial rituals and their forms of subjectivity and identity, juggling these with the limitations in spatial and financial resources that much of the expanded bourgeoisie faced.

To this end, Freud's output was eclectic, forming itself around the varied tastes and lifestyles of his clients, rather than offering a one-size-fits-all solution. Welter traces the influence of Loos on Freud, who took from him not the dogmatism of the famous dictum that ornament is crime, but rather the precept that the architect should not impose taste or style upon his clients. An example of such eclecticism in Freud's work is the house he laid out for his father in London, a masterpiece of restrained Viennese fin-de-siècle pomp, orchestrated functionally around the Freud family's rituals of work and leisure: hardly an example of purist geometry, or of the famous modernist open plan, but nonetheless animated by a modern sensibility towards light and openness.

One of the most illuminating and original chapters of the book compares Freud's and Loos' projects to the poetry of Rilke (of which Freud was an enormous fan). Rilke's poetry neither sought pure subjectivity (as with expressionism), nor to embrace the pure objectivity of the realm of commodities. Rather, it sought a relationship between the poet and things where, as 'animate objects', they might be gathered around as mediating presences to create the poet's humanity itself. Similarly, for Freud, 'to create a home was not primarily about the fulfilment of minimum spatial requirements ... Instead it meant to conceive houses which the occupants and their animate objects could fill so that both together would create the home and thus come alive.' For Freud, then, architecture comes close to continuing, in built form,

his father's therapeutic project, concerned as it is with 'interiority', and with the family scene in which the psyche and identity of the bourgeois individual is formed. Given such a sympathy with psychoanalysis, it is hardly surprising that, as Welter documents in detail, Freud went on, alongside his domestic work, to design consulting spaces for psychoanalysts.

Though Welter does not fully follow up on tracing how Freud's buildings carry out such a project of mediating presence, Welter's book nonetheless offers us a patient and scholarly anamnesis of the architect's work. In keeping with Freud's own practice, Welter places the architect's relations with his clients to the fore, rather than an overarching narrative of architectural-historical development, and the book thus develops an anatomy of the modes of life of the various middle-class customers that Freud served, each with a very different set of requirements. The book is at its best in its detailed discussions of the buildings in these terms – its high point is the analysis of Freud's 1928 weekend retreat for Theodor Frank, manager of the Deutsche Bank. Here, Freud, negotiating complex tensions between the needs for appropriate formality and informality in the entertainment of both intimate friends and business guests, assembled a set of spaces into a machine to serve the complex rituals of high-bourgeois social life. The concerns in organising such a space are very different though, for example, from those of the many homes Freud designed for psychoanalysts, balancing consulting rooms and domestic life, or again for Ernst Freud's own London home, which Welter describes as working to compress bourgeois luxury into the confined space of exile.

Where the book disappoints, however, is in fully anatomising the class origins of Freud's clients. An early chapter comments on the somewhat complex nature of the 'bourgeois' class of the early 20th century, especially in relation to the growth of the white-collar workers described by the German theorist Siegfried Kracauer, and the permeation of highly variegated (quasi-)

bourgeois forms of identity throughout society – all with the haute bourgeoisie as their role model. Unfortunately, such insights rarely make their way across into the detailed and more empirical work on the buildings themselves that take up the bulk of the book, which offers little extended reflection on the similarities and differences between the class status of Freud's different clients. This, it seems to me, marks the limits of Welter's work as a liberal paean to an architect of the bourgeoisie, rather than radical critique. The radical promise of Welter's book is that in order to understand and fully critique modernism, we need to understand its (often disavowed) relationship with the bourgeoisie. Welter, at his best, offers a deepening understanding of this class – which in the 1920s was perhaps at the height of its power. To the extent, however, that Welter pulls back from following through with this project, it loses its critical bite, and even serves to normalise and celebrate, through the persona of Freud, the ethos of that class.

This is, perhaps, of even more importance if we, unlike Welter, start to ask questions about the relevance of the modes of domestic living developed by the early 20th century bourgeoisie to the present day. In a time when increasingly people identify themselves as middle class rather than working class, we are all heirs to Kracauer's 'salaried masses'. The aspiration to – if not the actuality of – the bourgeois blueprint of modern domestic life has been taken up, it seems, universally, along with its spatial forms of the home. There seems much to question here in the wake of the 'credit crunch'. This started with the crash in speculation on American 'sub-prime' home-owner loans for those in the poorer reaches of society who had been given a sense of entitlement – if not obligation – with regard to bourgeois architectural domesticity which ultimately, it seems, many could not afford. Whether our society might be able to live up to such promises, and, if not, whether there are other ways that 'home' might be more equitably organised thus remain pressing questions. These,

indeed, would be good ones to motivate a 'return to (Ernst) Freud', though I fear this motivation is not Welter's. At worst, Welter's celebration of an architect of the upper-middle-class twentieth-century interior might bolster the continued embourgeoisement of domestic space and of our value system.

At best, however, Welter's detailed account of Freud's oeuvre and his relation to his clients recovers, if in a still-somewhat-empirical vane, vital material for understanding aspects not just of the nature of architectural modernism, but also of a broader cultural modernity itself, a modernity which still impresses itself on the present day. This – quite aside from the inherent interest of an unjustly neglected architectural modernist, and of Welter's riposte to architecture-historical orthodoxies about modernism – makes the book more than worth reading.

The Extrovert and the Introvert

Tom Snow

Mark Godfrey, *Alighiero E Boetti*
Yale University Press, 345pp ISBN 9780300148756 £35.00

The work of late Italian artist Alighiero Boetti (1940 – 1994) has proven a difficult fit within institutional discussions of art since the 1960s. Frequent association with the *Arte Povera* group (the term, meaning literally 'poor art' or 'impoverished art', was coined by art critic Germano Celant in the late 1960s and subsequently developed throughout the 1970s), has seemed equally problematic insomuch as the term accounts only for the earliest elements of the artist's widely varied production. Briefly summarised as a commitment to contingency, intent on identification of the world in the present, many of the artists Celant would highlight focused on the industrial climate and contemporary materials of northern Italy.

Mark Godfrey's monograph, the first to consider the artist's career in its entirety, represents a major step forward in the reallocation of Boetti's practice through the writing of twentieth century art, arguing that the artist should occupy a major position in recent art history. At the heart of Godfrey's survey are the artworks themselves, considered through an interchangeable range of thematic groupings rather than accorded to any strict biographical or linear narrative. Drawing upon an erudite range of comparative practices, particularly contemporaneous American Abstraction and its European counterparts, Godfrey reimagines Boetti's art, not just through a broadening of reference points but also through a consideration of his continued influence today.

The difficulty of Boetti's place within Turinese *Arte Povera* is

dealt with in the second chapter, 'Hardware Shop Moments: The *Arte Povera* Years.' Rather than argue for, or reconstitute a position within, established discourse Godfrey points out that Boetti's brief flirtation with the aesthetic (c.1966 – 69) came at a time when the term was being 'tried-out and tested' and was therefore never anything 'solidified or a movement to join.' Works such as *Catasta* (*Stack*, 1966) – made from industrially produced Eternit tubes – are thought about as 'artless constructions' or 'dysfunctional designs,' stacked but not fixed and ready to topple over with any intervention. Beyond alignment with the 'aura of labour and industry,' as the contemporary work of Richard Serra and Robert Morris might be considered, these constructions targeted a conservative trait of sculpture. On the one hand, the materials were emancipated from their usual functional roles and validated as artistic materials according their place in the everyday environment. On the other, the absurdity of these *artless* constructions alluded to a nationalist imaginary, which championed aspects of Italy's cultural heritage and traditional modes of art production despite ready and recent association with the rhetoric and ideology of Fascism.

Dual or multiple positions, including the above, are central to Godfrey's concerns during his examination of Boetti's work. Rather than any forthright claim towards a binary opposition, Godfrey considers that one of the most crucial aspects in understanding this artist is to take seriously Boetti's own conception of the artist as a split subject. The claim that Boetti oscillates between a kind of *everyman* and a *magical figure* is expanded through discussions of the 'schizophrenic artist.' This idea is perhaps best associated with contemporary texts such as the endlessly influential *Anti-Oedipus* (Editions de Minuit, 1972) by Gilles Deleuze and Félix Guattari, as well as the writings of Franco Basaglia. Coincidently, in the year that Deleuze and Guattari published the first part to their philosophical project *Capitalism and Schizophrenia* (1972), Boetti was to change his name

to Alighieri *e* Boetti (Alighieri *and* Boetti). Read as a move to distinguish between the surname as a label of late capitalist social categorisation (the artworld, national registers etc. – a kind of branding), and the intimacy he shared with those on a first-name basis, this argument becomes a governing factor for much of the study. Whilst a claim to the direct impact *Anti-Oedipus* could have had on Boetti's thought is avoided, the text is used in order to advance how one might think about the complex issue of a split subject.

Understood to embrace the constant operation of conflicting 'desiring-machines', rather than conform to a reductivist organisation of flows decoded via psychoanalytical moulds such as the Oedipus complex, an understanding of Boetti's production is initiated whereupon difference is maintained in the conception of artworks rather than rejected or resolved. Various self-portrayals testify to the reclamation of irrationality alongside reason, perhaps most notably the 1968 photomontage *Gamelli (Twins)*, where Boetti appears to be holding hands with his double. At first glance both figures appear identical, in dress as well as stature. However on further inspection subtle differences come to light. The Boetti on the right seems to be smiling and looking directly at the camera, as though completely relaxed in the public context of the pictured boulevard. The figure on the left appears to wear a more introverted expression and directs his gaze ever so slightly away from the camera lens in order to represent, according to Godfrey, two faces of the artist – 'the extrovert and the introvert.'

The pairing of post-structuralist thought with an idiosyncratic conceptual artist like Boetti might seem a daunting prospect for the reader. However, what Godfrey actually offers is a lucid commentary, managing an impressive balance between thoroughly considered, precise observations and an accessible writing style. The favoured position of multiple creative possibilities over a singular artistic position is developed with regards to

several of Boetti's productive processes, most of which would span the rest of his career. It is notable that Godfrey forgoes the temptation to analyse or over-celebrate the artist's whimsical character, instead favouring an account of the formal qualities of artworks interspersed with useful anecdotes that add to an overall understanding of a richly illustrated creative pursuit.

The well-known *Mappe* works, alongside other long-term projects, are considered as 'non-collaborations' in the sense that little supervision was offered during their embroidery in Afghanistan (and later Pakistan). In fact, Boetti was never to meet with most of the people producing his work in foreign workshops; instead he delegated coordination out to others and even allowed decisions to be made by the embroiderers themselves. Aside from geopolitical concerns evident in representations of fluctuating national borders in the *Mappe* works, it is through 'multiplicitous' stages of production that Godfrey complicates his understanding of Boetti's practice. In a chapter entitled 'The Four Fundamental Concepts of Boetti's 1970s Works,' four major conceptual positions are developed according to the artist's own claims. *Mettere al mondo il mondo* (putting the world into the world/ giving birth to the world) for instance is a phrase which appears in various places throughout Boetti's oeuvre, including the edges of some of the *Mappe*.

Here, several possible meanings of the phrase are unpacked, demonstrating the extent of readings the maintenance of multiplicity might allow. If the two-dimensional depiction of global space is an accepted occidental abstraction, what sort of dialogue might the production of this image of the world initiate when abstracted to the level of nationalistic symbols of unity (flags)? This, especially, during moments when large groups of people were forced into economic or political migration. But also, how might that idea contrast with the reception of such an image in a contemporary art institution when, as Godfrey claims to have witnessed, visitors tend to gather around the works and happily

point to countries here and there, spotting various flags? The split or division based on the artist therefore is not understood only as a bifurcation of identity, but also as a kind of schizophrenic distribution that registers potential political associations as multifarious and experiential.

In addressing artworks in their contemporaneity as well as through various and potential legacies, Godfrey offers critical perspectives from which to reflect upon an endless oscillation or dynamic that individual pieces – it is claimed – invite. Through an alignment with Boetti's own philosophical arrangements such as *mettere al mondo il mondo*, Godfrey guides the reader of this monograph through an assemblage of ideas grounded and supported by an impressive breadth of research. This, in my view, is a powerful position to take. Not only is analysis of the artist's oeuvre considered through an attendance to the artist's own theoretical and philosophical positions, but discussion is also furthered through strategic engagement with existing institutional discourse.

Rather than producing a straightforward polemic regarding Boetti's position within 20th century art history therefore, the artist's contribution is sensitively measured and allowed to emerge as a significant moment in recent European art through a celebration of his diverse artistic ingenuity. The question that this study raises therefore is: if Godfrey convincingly argues for the central location of Boetti's work within 20th century art history, which is not apparent in existing literature, what other blind spots might be identifiable through further research of this kind? Despite current academic focus on *Arte Povera*, what might Boetti's seemingly radical departure tell us about its conceptualisation and its usefulness as a reference point to Italian art beginning in this period? Especially considering that Godfrey's approach is not an exhaustive one, but an experimental one in this regard.

A penultimate chapter is dedicated to Boetti's 'paper works,'

which have enjoyed little critical attention until now. During the frequent production of embroideries and other large-scale delegations outside of the studio, hundreds of drawings, collages and stencils were made day-to-day by the artist using whatever materials surrounded him, right up until 1994. Contrary to viewing these works as initial deliberations or preparatory sketches, they are discussed as a compensatory medium, an alternative venting of ideas whilst he instructs or waits to receive outsourced material. What is intriguing about Boetti is that the majority of his artistic productions ran parallel, yet there exists a multitude of ideas that clearly transverse his thought process at variable and often irregular points. Notable here is another of Godfrey's 'four fundamental concepts,' *ordine e disordine* (order and disorder). This can be confusing and might begin to explain Boetti's absence from collective art histories. It is Mark Godfrey's achievement then, to manage and sustain a reading of Alighiero Boetti's work that sensitively orientates its way through a conceptually complex body of work, allowing for diversity in approach that matches the diversity of this artist's practice.

A Cottage Industry

Andy Murray

David Berry (ed.), *Revisiting the Frankfurt School: Essays on Culture, Media and Theory*
Ashgate, 218pp ISBN 9781409411802 £55.00

There are few categories in the history of Marxism as indeterminate as that of 'Frankfurt School'. Since this term came into common parlance in the 1960s to refer to the associates of the Institute for Social Research in Frankfurt, it has often been used simply to refer to Theodor Adorno and Walter Benjamin. These two have become the subject of an academic specialisation that produces a massive output of publications and symposia, a cottage industry its own right. The bright light concentrated on these two personalities has left many other associates of the Frankfurt Institute in their shadow. All too often, mention of 'a Frankfurt school argument' is intended to refer to the arguments in Adorno and Max Horkheimer's *Dialectic of Enlightenment* (1944), or more specifically, Adorno's chapter on the Culture Industry, or even just the concept 'culture industry' itself.

Although assessing and rebalancing this situation would undoubtedly be the work of more than one publication, *Revisiting the Frankfurt School* contributes to such a project. The book collates nine essays from nine different scholars, most of which are dedicated to a particular associate of the Frankfurt School. The general approach of these essays involves asserting the importance of these associates for contemporary leftist praxis, examining the theoretical and historical importance of relatively minor figures to the Frankfurt school and assessing their importance for the development of modern media and cultural studies. This method is in marked contrast to the trend in scholarship

which asserts the importance of central figures (particularly Adorno) and which rereads the Frankfurt school in light of later developments in continental theory. This collection therefore is an interesting counterpart to another collection of essays, *Rethinking the Frankfurt School* (SUNY Press, 2002), edited by Jeffrey T. Nealon and Caren Irr, which is structured on this contrary model.

In valuing the radical politics of the Frankfurt School many of the essays revise the caricature of the Frankfurt school as scholastic, i.e., a set of academics whose work has little investment in actual class struggles. Philip Bounds' essay is a valuable contribution to this reoccurring debate. He shows that Herbert Marcuse's response to the New Left in the late 1960s reveals that 'pessimism' and 'optimism' are, with regard to political struggle, complex terms that dialectically pass into one another. Marcuse's optimism towards the New Left is shown to involve a pessimistic undertone in supporting movements whose radical demands were often knowingly self-defeating; whereas Adorno's active pessimism towards student demonstrations contains an element of hope for a more productive political movement.

A few of the essays convincingly demonstrate the importance of the Frankfurt School for contemporary leftist politics, particularly in relation to new internet media such as social networking. Julian Petley argues that Habermas's narrative of the 'refuedalization' of the public sphere during late-capitalism – a process whereby the media is transformed from a space of communicative action to one primarily concerned with limiting the development of collective consciousness – can, in light of Habermas's own revisions of this theory and of the development of new media technologies, be used to understand and determine new forms of anti-capitalist strategy. Mike Wayne has a similar purpose in his essay on Hans Magnus Enzenberger, in which he makes a bold case that Enzenberger's essay

'Constituents of a Theory of the Media' is as important for under-
standing popular collective consciousness in a world of social
networking as Benjamin's 'Work of Art' essay was for the decades
of developing cinema.

Other essays focus their research on the formative devel-
opment of their subject and the impact of the Frankfurt School's
historical context. The strongest works in this regard are by Alan
O'Connor and Caroline Kamau. O'Connor's compellingly argues
that some of the oddities and contradictions in Benjamin's
thought are not due to his personal quirks, but are instead
responses to the intellectual environment of interwar Germany, a
context he adeptly models using social categories elaborated
from the work of Pierre Bourdieu. Kamau, pointing out that Erich
Fromm was the originator of the key concept of the 'authoritarian
personality', shows his decisive impact on the Frankfurt School's
research. If Fromm is today a less studied figure, it is because he
was estranged from Horkheimer and Adorno due to both
personal and methodological differences.

Fromm's methodological distinctness partly hinged on the
weighted importance he gave to quantitative as opposed to quali-
tative analytical methods. He thereby anticipated a key divide
that separated the Frankfurt Institute from American communi-
cations studies during the post-war decades. The dialogue
between German and American scholarship is explored at length
by Hanno Hardt in his discussion of the development of the
thought of Leo Lowenthal, a Frankfurt Institute member whose
critical-historical approach marginalised him in American
departments. Hardt's essay is an updated version of an essay
published in 1992. Yet, its inclusion in this collection is
productive, especially when read against Robert Babe's essay
comparing the concepts and methods of Adorno to the Canadian
scholar, Dallas Smythe. Babe shows that even a leftist like
Smythe, whose concept of the 'consciousness industry' shares
much which the concept of the 'culture industry', still had

methodological disputes with European Marxists.

This essay collection as a whole does therefore offer an important and often understated set of perspectives on the Frankfurt school. However, I have two reservations. First, two of the essays have limited use value. Sanda Miller's essay on Siegfried Kracauer is overloaded with analogous and vague comparisons of Kracauer's work with that of so many other intellectuals that none of these achieve any substantial depth. Furthermore, a series of glaring inaccuracies (or, at best, very clumsy wordings) does make one wonder whether the author herself understands the social and intellectual culture in which Kracauer's work developed. We read, for example, that 'Baudelaire invented "modernity",' '[Meyer Schapiro] was the first to introduce Marxism as a methodology in art history,' and '*Historicism* … was the revolutionary new methodology proposed by Georg Wilhelm Friedrich Hegel.'

Similar limitations apply to the essay on Max Horkheimer by David Berry. Berry's essay has a promising element in that it reads Horkheimer's pessimism and later theological turn as being of Schopenhauerian influence. An examination of this would have offered a fascinating perspective on the Frankfurt Institute as a whole, whose philosophical genealogy is dominated by the trio of Kant, Hegel and Marx. Unfortunately, this line of enquiry is not explored in detail, and Berry's essay turns instead towards a lengthy comparative reading of Horkheimer's philosophy with that of Francis Fukuyama, a figure so polarising that the comparison hardly seems worthwhile.

My second reservation is that this book is, in some respects, poorly edited. The Berry and Miller essays in particular are badly structured, containing repeated points and ungrammatical sentences. There are fewer problems with the other essays, but repeated sentences and typos occasionally surface. Such sloppy editorship has important negative implications for the

substantive quality of the collection, as the book's general framework is poorly defined. The editorial introduction is sparse, and none of the essays question the terms used throughout the collection with regard to the Frankfurt School.

A discussion of the problematics surrounding the use of the term 'Frankfurt School' as oppose to the Frankfurt Institute of Social Research, as well as terms such as 'first', 'second' and 'third generation members', 'members' as oppose to 'associates', and even 'inner' or 'elite' figures as oppose to 'outer' or 'marginal' figures, would have helped framed the debates of the ensuing essays. An essay dealing with both the genealogy of these terms and their historiographical development in the works of the Frankfurt School historians Perry Anderson, Martin Jay, Rolf Wiggershaus and Thomas Wheatland should have been essential to this collection.

In the absence of a nuanced enquiry along these lines, it is questionable whether this collection can really serve to revise our understanding of the Frankfurt School. Indicative of the book's limited ambition is how Adorno remains treated as a central member. Out of the nine essays, only one, Julian Petley's essay on Habermas, excludes any significant mention of Adorno. In six out of the other eight Adorno is a key figure used in a comparative analysis with the essays' main subject. It is not clear whether this pattern occurs because of Adorno's decisive influence on these Frankfurt School associates (indeed, this might even be a tacit definition of a Frankfurt school associate), or whether our contemporary knowledge of Adorno is simply much stronger than most other associates of the Frankfurt School. That the former of these statements is a condition of the latter does not disentangle this problem. Unless this issue is addressed, the model for research that runs throughout this collection resembles that of a bad wheel, whereby we can see the relation of Adorno in the centre to all the other figures, but it is harder to observe the relations between those 'outer' figures.

Nevertheless, even if *Revisiting the Frankfurt School* does not tackle this project, David Berry has contributed towards it by bringing together a set of essays that demonstrate the crucial importance of more neglected Frankfurt School associates to our understanding the history of the Frankfurt Institute, the academic disciplines of media and cultural studies, and the contemporary world.

The God That Failed

Benjamin Noys

Simon Critchley, *The Faith of the Faithless: Experiments in Political Theology*
Verso, 320pp ISBN 9781844677375 £16.99

The current obsession with religion in contemporary theory is hard to miss – what had seemed a secular enterprise has turned out more books concerning Saint Paul than the average theology faculty. Simon Critchley's new take on religion is, like many of these efforts, also an attempt, or as he prefers experiment, in 'political theology'. At the heart of the work is God-envy; an envy of believers for the motivational power of religion, which is not dissimilar to those annoying reports that religious believers are happier and have better community support than any benighted atheists or agnostics. Writing from the self-proclaimed position of 'post-Kantian, metropolitan, cosmopolitan metrosexual', a position readers are presumed to share, Critchley aims to take back this claimed motivational power without any of the irritating impediments of actual belief.

What is different about Critchley's experiment is that it tries to rework a 'faith of the faithless' for an anarchist politics. This book might be taken as an expansion of his previous work *Infinitely Demanding* (Verso, 2007), which set out a politics based on the weakness and frailty of the individual subject to an infinite ethical demand. Now, at much greater if not exhausting length, *The Faith of the Faithless* aims to cash out what that experience might look like, as well as modifying and reflecting on the 'anarchist' politics previously outlined. In particular, the core of this work is Critchley's suggestion of a 'politics of love' that can concretely embody this anarchist 'weak politics'.

Critchley's politics of love is ranged against the fetishisation of the state and power in political thought. He sees the limits of contemporary debate as being between Carl Schmitt – an ideologue of Nazism in the 1930s, and theorist of politics as a matter of sovereign decision - at one end, and 'Obamaism' – the 'liberalism' of Barack Obama - at the other. Critchley's anxiety concerning state power leads him to further dubious historical judgements, such as his claim that 'Jacobinism', which he charac-terises as a dictatorial political form operating through purifying violence, links together the violent excesses of 20th century politics, from Lenin, Stalin, and Hitler to al Qaeda. This kind of unnuanced collapsing of different movements and political forms repeats a similar gesture from *Infinitely Demanding*, and is unworthy of Critchley's project. It panders to conservative and reactionary tropes, and does not serve a proper historical awareness of the forms of state violence.

Matters are made more complex when Critchley chooses to articulate his alternative politics of love, a gesture of absolute spiritual daring, through what he calls 'mystical anarchism'. The confusion I felt is that this kind of 'mystical anarchism', associated with medieval mystics and the 'Brethren of the Free Spirit', itself seems like an absolute and abstract politics. Certainly Critchley stresses its self-abnegating nature, and is careful to distance himself from more recent manifestations of 'absolute politics', but there remains a sense of envy or desire for an absolute radicalism that is constantly warded off. This sits somewhat uncomfortably with his recognition that any contem-porary radical politics must involve a sense of the complex mediations involved in political activity and provide a careful mapping of forms of power and resistance. I'd certainly agree, but what is striking is that Critchley doesn't reference any real examples of such mappings, and so leaves the confused impression that somehow we can have the cake of absolute radicalism and eat it with an unspecified sense of 'concrete' nuance.

This strikes more generally at the tension in the book between the weak and powerless subject and the demand of the infinite Other. How is a demand supposed to come down to an earthly politics? The most interesting reflection on this question comes in Critchley's discussion of the 'heresy' of the Marcionist doctrine. In this form of Christianity, inspired by Saint Paul, there is an absolute split between faith and knowledge, the New Testament and the Old Testament, redemption and creation. Our world is a fallen one, and our only redemption comes through an absolute detachment from this world and our faith in a moment of redemption.

This stress on the absolute novelty of redemption is used by Critchley to diagnose a 'crypto-Marcionism' in certain forms of contemporary theory; he has in mind Alain Badiou and Giorgio Agamben. While I don't think this criticism quite hits its putative targets I do think it accurately identifies the tension in Critchley's own project. It suggests his awareness of the temptations of novelty and the extremity of a self-authorised politics of love. This potential self-criticism could be developed further, perhaps in a reflection on the dangerous 'concrete' results that can result from the 'absolute spiritual daring' of a politics of love. Here, as an aside, a viewing of Paul Schrader's Calvinist epic *Hardcore* (1979), with its Calvinist father trying to find and 'rescue' his daughter from the world of hardcore pornography, might illustrate the possible perverse results of such an approach.

These tensions come to a head in the chapter devoted to the debate between Critchley and Slavoj Žižek on the question of violence. Despite the seemingly high stakes of the debate, which Critchley represents as a restaging of that between Marx and Bakunin, something comic surrounds it. There is little more amusing than watching intellectuals descend into playground-level insults, especially when Žižek is renowned for his recourse to off-colour jokes and Critchley has written on comedy. In Critchley's telling, Žižek's defence of violence is another Leninist

fantasy that leaves Žižek caught in a deadlock between endorsing withdrawn reflection and fantasising apocalyptic violence. Leaving aside the accuracy of this judgement, Critchley's own attempt to mediate a thinking of non-violence that can guide us politically seems noticeably problematic.

First, we have the strange instance of an 'anarchist' thinker commending the Bolivian president Evo Morales against Žižek's choice of Hugo Chávez. Moving on, Critchley's attempt to articulate a more nuanced thinking of non-violence which is not absolutist leads to a 'nonviolent violence' in which our decisions are always guided by non-violence but may involve violence. While this is not necessarily bad, it hardly provides much in the way of political or ethical guidance or assessment; even the US military professes the desire to reduce violence to a minimum in its operations. Of course, Critchley argues that our own sense of powerlessness tied to the demand of the 'infinite Other' should produce better ethics than that. I was struck, however, that as the chapter went on it seemed harder and harder to detect any difference between Žižek and Critchley's respective positions, despite their 'violent' differences. Both seem to be saying - which is only what most of us would agree with - that violence is needed where necessary, but not too much violence.

This certainly speaks to a common impasse, as it is difficult to answer such questions at a time when the left and radical movements are in a state of weakness. The weakness in question is not Critchley's metaphysical weakness of the suffering self, so much as an empirical weakness. Debates concerning violence or non-violence, our respect or not for the 'infinite Other', and whether we are intrinsically powerful or powerless, obviously seem highly abstract in the absence of actual political action. Also, the problem of state violence seems much more pressing than the violence of the left, although accusations of 'violence' against protestors are endemic – as seen in the current and continuing prosecution of student protestors. In this situation

the analysis of how state violence presents itself as the lawful 'non-violent' restraint of 'violent protest' is the key problem.

Certainly Critchley has modified profoundly his anarchist views – including his doctrinaire and abstract claim to 'non-violence' – but so much so that they might not be regarded as anarchist any longer. His suggestion that we think more deeply about the locations of radical politics, and his suspicion of claims to novelty and absolute change, are vital in the present moment. What I doubt is whether invoking our powerless nature and the infinite demand of the Other really answers these demands.

Sketching Theory

David Winters

Terry Eagleton, The Event of Literature
Yale University Press, 256pp ISBN 9780300178814 £18.99

'Literary theory,' the historian Gerald Graff has remarked, 'is what is generated when some aspect of literature ... ceases to be a given and becomes a question to be argued in a generalised way.' Graff's definition might look like a platitude, but its prosaicness is its strength. It's surely the case, as Graff implies, that any systematic account of literature is always already 'theoretical.' With this in mind, theory should be understood less as a phase in the history of criticism – as in the so-called 'theory boom' of the 1970s and '80s – than as part of the grammar of critical practice. The assumption, today, that theory is 'dead' thus speaks not of the failure of some theoretical 'project,' but only of the critics' failures to reflect on their own ongoing theoreticism.

Terry Eagleton's career has covered the long arc of literary theory's fortune, from its institutional incorporation – a paradigm shift partly produced by his bestselling textbook, *Literary Theory* (University of Minnesota Press, 1983) – to its subsequent forgetting; its false overcoming. As he puts it, 'semiotics, post-structuralism' and so on are now 'for the most part foreign languages to students.' What has taken their place is a kind of uncritical culturalism; 'a shift from discourse to culture,' which often renders the object of study all too diffuse. An adjustment of focus from literary to cultural 'texts' may make the discipline seem more inclusive, yet it risks losing sight of what should surely be the crucial question of criticism: what is literature as such?

So, to treat literary criticism as a subfield of cultural studies is

to miss the specificity of literary experience. Against this trend, Eagleton's latest book, *The Event of Literature*, attempts to retrieve some of literature's strangeness and singularity. Indeed, it argues that critics should again (as they did in the decades of 'high theory') explicitly situate this singularity among their key concerns. In this respect, Eagleton makes a persuasive case for returning to what could be called 'pure' literary theory; a pursuit which would stress such apparently overlooked questions as 'what is fiction,' or 'what do all works of literature have in common?' To theorise in this sense is to reassert the centrality of close literary analysis, recovering literature as a determinate object of study, distinct from broader conceptions of 'culture'. For Eagleton, culture doesn't go all the way down.

Historically, however, literary criticism has always had to look outside itself for its own renewal and legitimation. Eagleton's new approach is no exception: he quickly finds that the fundamental characteristics of literature – what he calls its 'fictional, moral, linguistic, non-pragmatic and normative' qualities – have received far more comprehensive treatment from philosophers than from literary critics. In particular, he appeals to analytic aesthetics, arguing that this field 'contrasts favourably with the intellectual looseness' of mainstream literary theory. Insofar as the latter is marked by a 'continental' bias, and by a consequent one-sidedness about literature's philosophical import, the move is a bold one. Indeed, Eagleton's best attribute is his refusal to come down on either side of the unnecessary divide between 'theory' and analytic philosophy.

Literary Theory was notable for its deflationary tone; it never naively enthused about the ideas it explored. *The Event of Literature* possesses similar strengths. For example, Eagleton convincingly attacks the assumption (a commonplace among theorists since Jauss and Shklovsky) that literary language accomplishes a revolutionary 'defamiliarisation' of our routinised existence. As he argues, much theoretical rhetoric in

this vein 'takes it as read that common-or-garden norms and perceptions are impoverished, and that dominant conceptual systems ... are bound to be restrictive.' This is, he declares, 'a banal sort of dogma,' since 'not every margin is healthy, nor every system diseased.' Throughout the book, he refutes such conceptual simplifications, returning literature to the 'rough ground' of reality.

Yet if the exaggerated radicalism of theorists comes under scrutiny, so too do the trivialities of philosophers. For instance, Peter Lamarque is lambasted for his circular account of literary value. As Eagleton summarises, this approach reduces 'valuable literary works' to 'those which prove responsive to the normative reading strategies of the established literary institution.' On this model, then, 'a literary work, like an affectionate pet, is one which responds positively to a certain way of being handled.' This institutionalist tendency is not only tautologous; it inevitably tilts interpretation towards positive evaluation. For Lamarque, that a literary work 'is rewarding' is a precondition of its being counted as literature. His philosophy thus leaves no room for a truly critical engagement with literary texts. It places evaluation prior to interpretation, resulting in a conservative kind of belle-lettrism.

The Event of Literature covers an ambitious amount of ground, and as a result its arguments are frequently framed in generalities. As in his other recent books, Eagleton's broad brush strokes are both a strength and a weakness. They're a strength in that they enable him to uncover the commonalities (what he calls, with Wittgenstein, 'family resemblances') between a diverse set of thinkers and theorists. But, here as elsewhere, Eagleton has a weakness for straw men. One such would be Paul de Man, of whom he announces, 'for this Nietzschean theorist the world itself is a linguistic construct' – to which one might answer: no it isn't, and nor was it for Nietzsche. At his most glib, Eagleton isn't as funny as he thinks he is: 'if the theorists are open-neck-shirted,

the philosophers of literature rarely appear without a tie,' runs one dreary routine. A more serious shortcoming is that his rhetoric of robust 'common sense,' which deploys everyday counter-examples against the confusions of theorists and philosophers alike, often only holds up at this anecdotal level. In such cases, when Eagleton ranges competing ideas against each other, it's pretty clear that he's the one pulling the puppet strings.

Indeed, Eagleton spends slightly too much time demolishing others' arguments, or dubious representations thereof, and too little developing his own contribution to literary theory, which is largely confined to his last chapter. This is all the more unfortunate, since his approach is a rich and promising one. It revolves around a reassessment of literary works not as straightforward reflections of the real world, nor as autonomous artefacts, but as pragmatic strategies; as projects which seek to solve problems. Hence, literature tries to contain reality's contradictions, while at the same time reproducing them, in such a way that each work is an ongoing (indeed, interminable) 'event.'

As Eagleton argues, 'the literary work conjures up the context to which it is a reaction,' in the process 'throwing up problems, which it seeks to resolve, creating more problems.' The idea suggests a productive unpicking of ingrained distinctions between the form and content of literary works, between their performative and constative aspects, and even between their interior and exterior. Yet as it's presented in *The Event of Literature*, it doesn't feel like much more than a sketch. A longer, less diffuse account would be required to turn it into a fully-fledged literary theory. In this sense, Eagleton may have mapped a route towards theory's renewal, yet it will remain for others to follow it.

The Hipster Myth

Sebastian Truskolaski

Jake Kinzey, *The Sacred and the Profane: An Investigation of Hipsters*
Zero, 77pp ISBN 9781780990347 £9.99

Jake Kinzey's book-length essay *The Sacred and the Profane* is the latest offering in a slew of recent titles concerned with an elusive cultural phenomenon – the hipster. The blurb at the back of the book lays out the task ahead: to answer questions like 'Why don't hipsters want to be called hipsters?' and 'Why do they act like they are different when they are just like all the other hipsters?' Apparently, 'If you can't stand hipsters, are a hipster, or don't know what a hipster is, this book is for you.' Kinzey, a student at McGill University (Montreal) sets out to tackle these issues in three chapters: a brief introduction, involving a typology of the hipster ('ironic postmodern-kitsch zombies'); a correspondent genealogy from Nero to bo-ho; and an account of the hipster's alleged 'passion for the real'. Kinzey's monumental task, then, involves nothing less than characterising all the conceivable ills of late capitalism – from the gentrification of Brooklyn to the impending ecological catastrophe – through an account of what constitutes a hipster, elaborated over some 70 pages.

The opening passages of the book serve to set Kinzey's terms. The hipster, we are told, is a social-phenomenon characteristic of late capitalism. He is young and urban, possibly works in a 'creative industry' of one sort or another (or maybe he's just 'slumming it'), drinks Pabst beer, smokes Parliament cigarettes and wears American Apparel. Moreover, hipsters are said to stand at the end of a long line of subcultures that – each in their own way – opposed the mainstream: 'Beats, Hippies, Punks,

Hip-Hop' etc. Only, somehow the hipster is *different* ... Despite the truism that all of his antecedents surrendered what little spark they may have possessed to the Culture Industry without much resistance, Kinzey appears to find the failure of the hipster to usher in the classless society *particularly* reprehensible. (One wonders: was this ever at stake in the hipster's self-understanding?) The hipster's lack of passionate belief in anything – his callous posturing – we are told, means that '*selling out is practically programmed*' into his constitution. Kinzey characterizes hipsters as loathsome ironists: *the* postmodern subculture as such. 'Nothing they do is really *new*, it's all about sampling, bricolage, remixing, or, usually, just stealing wholesale from the past.' That is, hipsters tread that uneasy line between seeking to resist the logic of capital by recourse to some vague notion of 'authenticity' – a return to a genuine sense of subversion in the past, perhaps – and an ironic distance that mocks the very notion that resistance should ever have been desirable or possible.

Kinzey's account is problematic because it demarcates the hipster as somehow undermining the noble causes of preceding subcultures, without recognizing that the distinction is wholly cosmetic. Whether you live in a social centre and wear a battered leather jacket with a Crass patch on the back; or whether you live in Dalston/Williamsburg and ride a fixed-gear bike is completely inconsequential from the standpoint of capital. This is what makes it so insidious. Ultimately both models will be recuperated and sold back to you in one form or another, not least, perhaps in the form of this book. Even if one were to distinguish between more or less successful attempts by the youth to 'stick it to the man' – from Bob Dylan to John Maus – the characterization of hipsters in terms of bricolage is unconvincing. What is punk – not to mention hip-hop – if not collage?

Kinzey then proceeds to advance a bewildering analogy between the Roman emperor Nero and modern-day hipsters. The author's assurance that his book must be viewed as a kind of

'pastiche' doesn't quite cover how preposterous this comparison is. This is followed by a seemingly unrelated account of hipsters (or was it artists?) moving to crumby neighbourhoods and driving up prices. Whilst this may indeed capture some half-articulated truth about gentrification, it leaves one wondering why Kinzey is singling out what – according to his own account – are, presumably, twentysomethings with either student loans or woefully low incomes, as the agents of this development? Could one not equally have argued that CBGB's and its crop of arty proto-punks ruined the bowery back in the early 1970s? And would this not undermine Kinzey's tidy distinction between the heartfelt sincerity of punks and the obnoxious indifference of hipsters? Following this excursus, Kinzey proceeds to speculate over the pre-history of the hipster. His musings are undifferentiated, conflating snobs and dandies, flâneurs and bohemians in a one-dimensional account of art history that leaves much to be desired.

The claim that the avant-garde recoiled 'in fear before the image of a Fordist automaton ... seeking refuge in a *unique, personal* or *authentic style'*, for instance, is simply untrue. One need only consider any number of heavy-hitting examples, from Futurism to Warhol, in this regard. Kinzey's account of 'Garbage, The Sacred Place, and the Hipster Aesthetic' – as one of the sub-headings in Chapter Three reads – similarly misses the point. If we are to understand the hipster's alleged penchant for postmodern 'dumpster chic' as an abandonment of modernism's earnest endeavour, then what are we to make of Marcel Duchamp's urinal, or Kurt Schwitters's Merzbau? Kinzey's recourse to Zizek's reading on this point is too linear, too tidy. In fact, the very crux of Kinzey's argument falls prey to this critique. As he argues: bohemians are historically aligned with realism – their correspondent historical epoch is that of 'national capitalism'; the avant-garde is associated with modernism – its correspondent economic system is 'monopoly capitalism'; and,

finally, the hipster corresponds with postmodernism – its economic model is that of *'late* capitalism.' Bam! From Montmartre to late capitalist dystopia in three easy steps. And who spear-headed this development? The artist-bohemian-avant-garde-hipster.

Chapter Three marks Kinzey's attempt to align his reading of Alain Badiou's notion of a 'passion du réel' with the hipster's un-reflected worship of all things 'retro'. 'The hipster's passion for the real is expressed in their longing for authenticity, coupled with nostalgic mania, the mad-dash for the real located in a former time.' But what of it? At worst, this marks hipsters as yet another failed attempt of the youth to engage with pop culture in a meaningful way. That is not to say that Kinzey isn't correct in identifying that the taste for distressed denim pre-inscribes articles of fashion with dreamt-up narratives of labour and toil. But, surely, whether jeans are frayed or not, or – indeed – whether consumers imagine themselves to be gold rush renegades or not, is simply not the issue. Kinzey's wholly unconvincing account of the hipster as recalling a desire for all things rustic and völkisch ('authentic') is at odds with the irony he ascribes to them. Are hipsters obsessed with 'authenticity' or do they endlessly ironise? Kinzey's demand for the 'truly new', here, is simply misplaced. Surely it is clear that the marketplace is not the site on which the 'new man' that Kinzey so emphatically seeks to summon shall be forged.

The closing section on 'Why Hipsters Don't Call Themselves Hipsters' also feels contrived. Hipsters do not call themselves hipsters, because – on the model that Kinzey is proposing – 'hipster' is only ever a pejorative term. There is no *sensus communis* regarding what constitutes a hipster, no 'movement' beyond vague generalities imposed from outside. (Hipsters are aloof and wear bobble-hats etc.) The fact that hipsters 'are not "unique"' is not news. Nor is it particularly anything that anyone falling under that rubric might even claim. Moreover, this is not

an insight limited to hipsters. Yes, 'Being cool takes a lot of (…) immaterial labour. Hipsters are' indeed 'part of the laboratory of fashions and tastes which designers can then expropriate for their own benefit.' But so is virtually *everyone* under the sway of capital. When Jerry the Jock 'likes' his favourite sports team on Facebook he is as engaged in the machinery as those who order Marx's *Capital* from Amazon. 'Hipsters' are no more the problem than the Starbucks-sipping yuppies that follow in their wake. In fact, this kind of typology is – at best – a dead end.

Kinzey's closing remark that 'the hipster does not represent ultimate evil' is bewildering following his vitriolic diatribe. His assessment that 'Hipsters can attempt to be as "authentic" and "original" as (…) they like' since they are only 'clearing the ground for something new and world changing' seems dubious, to say the least: as though the hipster's happy romp through the pop-up bars and off-spaces of Neukölln resembled the biblical tale of Sodom and Gomorrah. The book half-recognizes a real problem that it is constitutively unable to address. The question, 'what is a hipster' remains unanswered. The question, 'what is to be done?' remains.

One-Dimensional Universe

Robert Barry

George Dyson, *Turing's Cathedral: The Origins of the Digital Universe*
Allen Lane, 432pp ISBN 9780713997507 £25.00

In 1983, the American film *WarGames* ended with a computer called Joshua suffering a nervous breakdown when it realised that thermonuclear war, like tic-tac-toe, is a game you cannot win. The whole thing comes about because of a conversation held about an hour and a half earlier between Joshua, voice synthed and hooked up to a stereo hi-fi system in a suburban bedroom, and a teenage computer hacker named David Lightman (played by Matthew Broderick).

'Shall we play a game?' asks the computer.

'Love to,' Lightman replies. 'How about Global Thermonuclear War?'

'Wouldn't you prefer a good game of chess?'

'Later, let's play Global Thermonuclear War.'

A similar conversation must have taken place at some level fifty years earlier at the Princeton Institute of Advanced Studies when Joshua's oldest direct ancestor, the very first digital computer with its own stored programmes and light-speed random access memory, was set to work on its first task: calculating thermonuclear explosions. It was not until 1956, four years after the computer's sums saw fruit with the first H-bomb test at Enewetak Atoll, that one of the bomb's principal architects, Stanislaw Ulam, created a chess program for the Mathematical and Numerical Integrator and Computer (aka, the MANIAC).

Long before the first arcade shoot-em-up, the history of computing was marked through and through by games and

game-play. Before founding the Electronic Computer Project at the Institute of Advanced Study, mathematician John von Neumann had co-authored, with Oskar Morgenstern, a volume called *Theory of Games and Economic Behavior* (Princeton University Press, 1944), which would provide the foundation for the 'game theory' soon to dominate nuclear strategy (and, later, economic policy). It was Ulam's fondness for playing solitaire - and von Neumann's for the roulette wheel - that led the pair to develop a class of algorithms for solving otherwise intractable statistical problems using computer simulations, which they christened 'the Monte Carlo method'. But even more than gaming, the history of the computer is marked by the shadow of thermonuclear war.

George Dyson was born in 1953 - just over six months after the first hydrogen bomb test - the son of theoretical physicist Freeman Dyson, who had been living and working at the IAS since 1948. So, in a way, it is quite natural that he should present the story of the Princeton computer project as something halfway between Biblical fable and light opera; these events were, after all, the backdrop to his childhood reverie. 'In the beginning was the command line,' he opens, before presenting a cast of 'principal characters' as if coming to the aid of some hypothetical future casting director. From there on in, Dyson oscillates between the messianic tone of the former and a series of cheerfully detailed biographical sketches on everyone and everything from the land on which the Institute stood to the lady who drew up the lunch menus in the canteen.

Turing's Cathedral might be read as an extended gloss on a book written almost half a century earlier. In 1966, Hannes Alfvén, the only physicist (Dyson informs us) to quit Los Alamos when it was discovered that the Axis powers were not seriously pursuing the atomic bomb, published a short dystopian science fiction novel called *The Great Computer*. The narrative unfolds like a wistful far-future fable, in which the appearance of the first

computer is reminiscent of the birth of Christ - in an old stable, attended by 'wise men' and the twinkling of stars. Alfvén pictures this idyllic scene against the backdrop of the mushroom cloud, for, as Dyson notes, 'The digital universe and the hydrogen bomb were brought into existence at the same time.' The story ends with a world dominated by supercomputers in which man has become superfluous. Aside from its considerably shorter length, the main difference between Alfvén's book and George Dyson's is that the latter is not a work of fiction.

It is hard to say whether the 'first computer' Alfvén had in mind was the Princeton machine or its twin at Los Alamos, or some other - perhaps earlier - invention. But for Dyson, the MANIAC was the first true 'Universal Turing Machine'. While devices such as the Colossus at Bletchley Park or the Moore School's ENIAC were built to perform specific functions, the MANIAC was built that it might theoretically perform any task that any computer might perform. This was the opening of a digital universe. In the mid-1950s, the Norwegian mathematician, Nils Barricelli, began to seed this universe with life - self-reproducing binary species, modelling a symbiotic evolution in the one-dimensional ticker-tape world of the Princeton computer.

In 1964, as Barricelli was claiming the first stirrings of intelligence in the virtual world of his mathematical simulations, Herbert Marcuse diagnosed a regime of 'one-dimensional thought' which was paralysing modern civilisation. One-dimensional society, Marcuse argued, flattens out contradictions, such that no apparent discrepancy might be perceived in an advertisement for a 'luxury' atomic bomb shelter. Meanwhile, a glib 'happy consciousness' prevails at places like the RAND Corporation where nuclear war is a parlour game played by top strategists in the building's lower basement.

In the same year, 1964, Paul Baran published a paper called 'On Distributed Communications' at the RAND Corporation, the organisation most concerned with the promotion of both pre-

emptive nuclear war and precautionary civil defence. Baran's paper laid out the basic principles of packet-switching, the division of a given message into small 'message-blocks' to be transmitted simultaneously along multiple routes of a distributed network. The purpose of Baran's paper was to suggest a telecommunications system that would survive a nuclear attack. From the mid-sixties, the nuclear strategists and systems analysts from RAND were moving into government, bringing to bear their computer simulations and Monte Carlo method in the design of Lyndon Johnson's 'Great Society'. While at the Defence Department research institute, DARPA, Baran's packet-switching was becoming the backbone of what would soon be renamed the Internet.

The anticipated apocalypse never came, but today we act almost as though it did anyway. Increasingly, we live, work, and communicate in the one-dimensional world developed at Princeton and Los Alamos sixty years ago. 'The entire digital universe,' writes Dyson, 'from an iPhone to the Internet, can be viewed as an attempt to maintain everything, from the point of view of the order codes, exactly as it was when they first came into existence' in the blinding flash of an artificial sun in the North Pacific. And the point of view of the codes, those simple strings of self-replicating numbers with which Barricelli first populated the digital universe, is increasingly our own point of view.

Marshall McLuhan used to talk about human beings as the 'sex organs of the machine world'. Thanks to the self-repro-ducing automata beloved of Barricelli and von Neumann, even this humble role is no longer required of us and we become, as in Alfvén's tale, mere 'parasites' on the computers. 'Evolution in the digital universe,' Dyson claims, 'now drives evolution in our universe, rather than the other way around.' Having created a star in Enewetak, the next step was to build a cosmos and inhabit it.

Future Past Tense

Rosa Ainley

Douglas Murphy, *The Architecture of Failure*
Zero, 167pp ISBN 9781780990224 £11.99

The joy of this book lies in the scope of its reference: from the 19th century to the as-yet unbuilt and unviewable. It takes as its first failure Victorian palaces of iron and glass and advances to Google Earth urbanism – renderings of impossible angles and locations which only a satellite can appreciate. The author's powerful critique of the supposedly radical proponents of architecture is brutal and incisive, a welcome move away from the well-trodden cultural clichés. *The Architecture of Failure* stands out in the growing contemporary literature on ruins for not communicating merely through the frisson of aesthetic delight and for choosing buildings of the late 19th century as its subject rather than those of the post-World War II period. Even if it were for these reasons alone, it is a useful addition and a corrective.

Given that architecture is never complete, is always deteriorating, never fulfils its intention or its promise or the expectations of users and instigators alike, *The Architecture of Failure* could be a very long book on the failures of architecture too. Instead it is short and bracing. It's refreshing to read work by one immune to the general swooning induced by certain figures in the architectural pantheon: Cedric Price, Buckminster Fuller, Archigram, to name a few whose limitations Douglas Murphy exposes. 'Solutionism' is his tag for this approach to architecture, less novel or surprising when attached to Foster and Rogers. Criticism is not only reserved for historical figures, however, Murphy is not partisan and is also unimpressed by the requisite genuflecting at the altar of parametricism, practiced by the likes

of Patrik Schumacher and Zaha Hadid (in what Schumacher strangely calls the 'new spaces' of airports and malls, when they are surely non-spaces and not new typologies). His term for this kind of work of 'essential flimsiness' is 'virtualism.'The third approach to architecture that Murphy identifies is 'iconism,' exemplified by Peter Eisenman, whose interpretation and co-option of philosophical ideas Derrida dismisses (in characteristically amusing fashion) as maladroit.

There is much to disagree and agree with here. The whimsy of Archigram, for instance, can be quite, well, irritating, but Archigram can't be held responsible for the current plague of popup fun, that scourge of organised spontaneity, in the form of shops/happenings/festivals. Murphy pushes this to the horrifying extremity of Bono being 'watched in a field by 50,000 middle-class people' and, indeed, scale is key: what might be an engaging idea at a small, localised level changes entirely when made ubiquitous and co-opted by the mainstream and the corporate. As Murphy notes, architecture is reliant on capital, to a greater extent than any other art form; its failures are very expensive, with the monetary being one of the least important of its costs. Nonetheless, he does concede that 'architects should not be afraid of failure', more than half way through the book. Do we hate architecture because it can't deliver (change the world) and love it because it tries? Can we, as it were, blame architecture for trying? And failing. Failure and optimism, though, are not mutually exclusive.

Murphy rightly bemoans the dreary chorus of 'blame the architect' for, as he asks (slightly in contradiction to his own thesis perhaps): since when did architects commission themselves? Equally unacceptable, in millennium project days, was the 'blame the engineer' stance over London's wobbly bridge, prefigured by the snobbish protectionism as the glass palaces went up in the 1850s – itself born of fear of de-professionalisation and industrialisation. In another instance of repetition,

the book mentions the security concerns about assassination, terrorism, violence, disease, infrastructural collapse: but it refers to the opening of the Great Exhibition, not the 2012 Olympics.

When Murphy states that 'the problems of architecture and its relationship to culture and technology are still unresolved today', it might be contended they always will be, because that tension is in large part what architecture is. Again, the statement that the profession is 'as far away from a revolutionary architecture now as we were at the time the iron & glass buildings emerged' appears superficially convincing, but is perhaps something of a blanket overstatement. This is a subject perhaps too big and deep to be entirely dealt with in such a slim volume and at points the density and compression of the prose might be doing its author a disservice. If architecture is necessarily situated in the future, and if all futures only exist in the past, what might happen if it were possible to situate architecture in the now? Also deserving of greater consideration is his discussion of how memories can only exist for as long as the space in which they occurred. As soundly rooted in theory as this book might be, it is also something of a call to arms, and one hopes that it is a but a taster for a much larger work to come.

The Last Word

Dan Barrow

Geoff Dyer, *Zona: A Book About a Film About a Journey to a Room*
Canongate, 228pp ISBN 9780307377388 £16.99

It's the image, perhaps, of the back of a man's balding head, bobbing slightly as he creeps towards a building where he neither wholly wishes to go, nor is wholly expected. Or a tracking shot of scattered coins, a Russian icon, lying on black and white tiles, under a glistering layer of water (a similar flicker – a *film*, notably, of flame in a grate – prompted Coleridge to reminiscence in 'Frost at Midnight'). Or a dog making its way without trepidation through the water on the right-hand side of the shot, paddling, in a sudden switch to colour, around the moored body of an explorer. Or, as on the jacket of Geoff Dyer's *Zona*, of a girl in profile, reading – perhaps, given its leather cover, one of the texts quoted earlier, Arseny Tarkovsky's poetry, or the Gospels – while a wind of dandelion seeds drifts slowly in through the window behind and over her head.

It's a question not of a film, a classic now absorbed into the canon of European art cinema, nor of the journey that forms its narrative, but of images that emerge from the stream of time, bobbing up to the surface like debris. *Zona* is 'an account of watchings, rememberings, misrememberings, and forgettings; it is not the record of a dissection,' and *Stalker* (1979), a film that conforms more thoroughly than any other to Deleuze's conception of cinema as a ceaselessly ebbing river of *dureé*, erases its own temporal tracks: the perceived length of shots blurs, the chronology of events and images becomes unstable, the Zone itself sends the protagonists round in circles. 'The Zone,' writes Dyer,' *is* film,' and Stalker and his companions enter into

cinematic time like Marlowe going up the Congo. In a certain sense the point of watching *Stalker*, like reading Kafka, is to re-watch it, to find out where these memories come from and, like the protagonist of Chris Marker's *La Jeteé*, to relive such moments in their full reality.

Stalker, when you come right down to it, isn't – contrary to the earnest viewers overeager to excavate its symbolism, its silences, the fraught meaning of its textures and the cinematic relationship with its environment – a *difficult* film. You just need to *look* at it. The film itself is intensely concerned with looking, with the need to divine a correct path through the Zone's apparently innocuous landscape, a responsibility commuted to the viewer in long takes of quasi-natural scenery, that seem to challenge the viewer to let their meaning arise out of their content, and Dyer is very good on the strange techniques the camera employs – as in the sequence when the camera looks, through the window of an abandoned car, out onto 'burned-out tanks', and the Professor, whose POV we assume this is 'comes into his own field of vision'.

With its fixation on post-industrial ruin, disordered and profuse nature, an extraordinary depth-of-field lending a strange lustre to its colours, the film presented an aesthetic that had no real precedents, apart perhaps from certain sections of Tarkovsky's own *Mirror*, and Antonioni's films up to *The Red Desert*. (The exquisite boredom of Antonioni's work is a running thread in *Zona*.) The extraordinary beauty of *Stalker* is that, as Dyer notes, of 'another world that is no more than this world perceived with unprecedented attentiveness.' If film was, rather than a technology, a way of seeing, that arrived not with the Lumiere brothers but with Méliès – just as, according to John Berger, oil painting really begins with Holbein – then the mode of attention in *Stalker* represents a kind of last flourishing of one revolutionary mode of mediation; Tarkovsky's patient expeditions into the world of the visible are a part, too, of Benjamin's 'optical unconscious.' In spite of his disdain for the tradition of

Soviet film, Tarkovsky's achievement belongs with that of Vertov and Eisenstein as much as it does that of Renoir or Bergman.

Dyer's book, at its purest, is about looking at *Stalker*: it consists, primarily, of a shot-by-shot description of what we see. Re-watching the film, Dyer's book reads, to me, as more redundant an exercise than other reviewers have thus far admitted. It possesses less acuity than Dyer's other exercises in amateur criticism – even than the (very good) miniature essays on submarine films embedded in the dialogue of his novel on twentysomething cinephilia, *Paris Trance* (Picador, 2010). What does distinguish *Zona* is the rhythm of Dyer's self-interruptions: at first in footnotes, then increasingly intermixed into the body of the text itself, these digressions, though usually far from critical thought, provide valuable reading. He is by turns wickedly funny – as in his dismissal of Lars von Trier's 2009 film *Antichrist* ('a highly crafted diminution of the possibilities of cinema') – droll, gossipy and moving. Most particularly, there's his discussion of his parents' strange wish 'to forego the thing ... that she [his mother] claimed she wanted.' His father's regret, expressed during his mother's terminal illness, that 'we didn't eat more fat' projects a future in which '[y]ou can go into the Room and eat all the fat you like *from now on*.' What the Room cannot do is alter lived time retrospectively – 'you can't transform the life you have led into one in which, even during the lean years, you ate heaps of fat.' (Dyer's own greatest regret, you'll not be surprised to learn, is of never having had a threesome.) But, as the Stalker observes, that doesn't mean that they don't keep coming, to have their desires perhaps granted them – he's not short of work.

The implicit question then, which comes more and more to the fore towards the end of *Zona*, is: what exactly do we go to the cinema for? What *temps perdu* could we recover in this repeated time of dreaming, brought face to face with a world larger than life? Tarkovsky himself seemed unable to answer: during his last

years outside the Soviet Union his public mood was increasingly bitter, as he railed against an apparently debased secular west, a film industry predicated on 'mere' entertainment. *Stalker* itself, as Dyer records, was plagued by problems. Footage shot over the course of a year, on experimental Kodak colour stock, had to be scrapped when it couldn't be developed properly. Tarkovsky secured funding for another attempt, but only enough to cover making Part 2.

Tarkovsky repeatedly fell out with crew members, going through three directors of photography in the course of filming. Shooting was repeatedly delayed by problems, and not everyone shared the director's monomaniacal concern: during one hiatus, according to cinematographer Georgi Rerberg, Tarkovsky announced a sudden return to work; Vladimir Sharun was then found applying potato peel to Alexander Solonitsyn's face 'to reduce the swelling caused by "the two-week binge."' Six years away from Glasnost, there was surprisingly little interference from Soviet authorities, certainly less than Tarkovsky would have experienced had he worked for a western studio. (Dyer mischievously notes in parentheses, 'How we loved making this point back in the 1980s!') Certainly his defection shortly after *Stalker* resulted in ever-diminishing cinematic returns: *Nostalghia* (1983) and *The Sacrifice* (1986) treat the language of his great '70s films as a repository of cliché; they seem almost paralysed by an earnest hopelessness bordering on the comic. *Stalker* itself answers the question only with, an interior shower of rain, a function of miracle or ruin, like light falling from what David Thomson has called 'the heaven of the lifelike'.

For Geoff Dyer, as he admits, *Stalker* might be the last time he sees that ('the projected colour lit up the screen,' says the narrator of *Paris Trance*, 'like Eden on the first day of creation'), might be 'the last word'. And perhaps not only for him. He is convincing and articulate about the contours of *Stalker*'s beauty, though the theoretical framework for understanding its significance is

almost entirely missing. One is left feeling ambivalent as to how satisfying *Zona* is in the end. *Stalker* certainly still lacks the monograph it deserves, and while Dyer's intuition that it requires a different approach from that supplied by institutionalised Film Studies – and, for that matter, the middlebrow press – is correct, that doesn't make *Zona* the book to supply that need.

Formal Wear

Hugh Foley

Glyn Maxwell, *On Poetry*
Oberon, 170pp ISBN 9781849430852 £12.99

Midway through *On Poetry*, the poet and playwright Glyn Maxwell stops to indulge in a nice bit of épatering of the bourgeoisie. Describing a fictional creative writing class 'moving short words millimetres backwards and forwards at the taxpayers' expense', he conjures the image of those philistine taxpayers, 'all the taxpayers in the nation … lining up to give young dreamers the hard earned money we'd planned to spend on crisps.' This is the closest Maxwell comes to mounting a 'defence' of poetry in the tradition of Phillip Sidney and Percy Shelley. Shelley's unacknowledged legislator becomes, as is the way of modernisation, an underappreciated civil servant. It is this creative writing class that centres Maxwell's argument about the forms and capabilities of poetry. It serves as a conceit for leading the reader through both reflections and exercises, as Maxwell demonstrates what undoubtedly makes him a fine teacher of the craft of poetry.

For Maxwell, poetry is at the front of humankind's never-ending battle against time. He quotes Delmore Shwartz's 'Calmly we walk through this April's day': 'Time is the school in which we learn / Time is the fire in which we burn'. His book is an elegant explanation of what poetry does, which is to use temporal features, the temporary patterning of an utterance to signify something more lasting, 'the coherent presence of a human creature'. This is in a sense what all language does; the tree does not stop existing when the word tree finishes its progress through the air. Poetry though, if it can be defined, is

perhaps the noticing of this gap between the immensity of the tree and the little syllable we use to point it out. It is a form of strenuous attention. The question is whether poetry rewards this attention or whether, as Maxwell somewhat dramatically puts it, you can 'see the whiteness eating away' at the words on the page.

It is to this end that Maxwell sets about exploring ways of enacting this struggle, showing how great poems reward attention to their form. His deft use of illustrative poems, including some well done forgeries and bowdlerisations (his version of Yeats' 'The Second Coming', written using only the vowels I, U and O, where 'things go to shit' is a particular highlight) helps to drive his argument that form is what a poet needs 'to go up against time'. Using the analogy of a violinist who refuses to learn anything from previous musicians, Maxwell makes a powerful case for the continuing utility of traditional forms and, indeed, of the necessity for some kind of order in the poem. Like the biblical parallel, Maxwell argues, wise poets build their house upon the rock of tradition.

It is on this question of form though that the limitations of Maxwell's argument become clear. 'Let's recite some we know by heart', he says of the kind of free verse that does not include 'Stein or Eliot or Pound or Jones or HD or Rosenberg or Williams or Bunting,' as if this were all that was needed to judge a poem's worth. If these are exceptions to his idea of free verse, it becomes hard to get a handle on what free verse actually is. It is undoubtedly true that the best poets are intimately concerned with the formal properties of their verse; it is almost tautological to say it but are mnemonic aspects, whether or not they are the root of poetry, the only necessary ones? There are hundreds of badly written and forgotten poems from every era, not because people did not use the historically accreted powers of traditional forms but because they did not use the given shapes effectively; they were not paying enough attention. Few people today read Richard Aldington or TE Hulme's imagism, and few people read

Wilfred Wilson Gibson or Ralph Hodgson's traditionally formal poetry. They read Eliot and Pound, they read Auden and Hardy. Maxwell knows that technique is everything in poetry, but the book rarely gets beyond the refinement of technique. At one point, he rightly mocks those who call him a 'neo-con' for using traditional forms, but if he thinks the minutiae of poetic technique have grand implications for the human spirit, and that if 'you master form you master time', why couldn't they have political significance? It may not be a fixed one, any more than forms have a fixed emotional significance, but within context all poetic technique is a kind of social practice.

Maxwell seems to create a straw man argument: a free verse poet who never has any desire other than to lineate his or her feelings. It is here that the institutional situation of poetry, cadging harder working people's crisp money comes into play. If there is one place this straw man might exist, it is in creative writing classrooms, among students who have yet to do enough apprentice work to improve their craft(how many poets now do a large portion of their thinking arguing with a student about the merits of not capitalising their 'I'?). Very few people are willing to pay enough attention to craft when they first start writing poetry.

The problem with Maxwell's argument is that he seems to conflate the problems that come from lack of attention, anti-formalism in the strict sense, with the issues thrown up by poetry that at first glance seems a million miles removed from traditional forms, but which reminds us that poetry is not about first glances. Writing about dangerous trends in contemporary poetry, he provides us with its main evils:

Formlessness says time is broken, Postmodernism thinks it's come to a stop and Obscurity can't even muster the nerve to look it in the eye. Three monkeys. Move on

He follows this up by paraphrasing his 'teacher' (who I assume is Derek Walcott) that contemporary poetry, if it takes these directions, will run the risk of not having any audience at all. A note of scepticism might be raised: Richard Wilbur or Tony Harrison hardly sell thousands of copies to teenagers who never buy other poems, or to those deprived of their rightful rhymes.

All recurring structures are a kind of obscuring of some ideal of prose sense, but in that obscuring they reveal other truths, are in fact the most efficient way of saying and embodying something. There is much poetry that does not look like 'proper' verse on the page, poetry which is obscure precisely because it embraces an extreme formalism but which still rewards attention. The work of people like the American L=A=N=G=U=A=G=E poets, or the 'Cambridge School' of British poetry is a mixed bag but when their 'obscurity' succeeds it is for reasons not so different from those that Maxwell demonstrates using his canonical examples of 'traditional verse'.

Maxwell rightly points out the historically specific nature of modernism's formal innovations, but this does not seem to stop him from claiming the physiological status of iambic pentameter, 'the line as long as a breath'. Poets with very different lines have also placed the breath as their unit of measure, from Charles Olson to Allen Ginsberg. The 'New Formalist' poet, Frederick Turner wrote an essay with neuroscientist Ernst Poppel entitled 'The Neural Lyre', where he argued that the poetic line was an innate biological fact, somewhere between 3 and 4 seconds in length (placing Iambic pentameter at a comfortable 3.30 seconds). Might it not be possible to argue that poetry is not about comfortably accepting limitations, even physiological ones? People cannot physiologically fly, but poets and writers more broadly have been giving voice to the desire to do so. Poetry might, in the process of constructing our attention, help the reader to realise more than the 'consistent presence of a human creature'. To embrace a tradition of challenging formal

expectations might be to expand the horizon of the way we look at people, to question our definition of coherent humanity, perhaps encouraging this latter idea more so.

Maxwell is right that those who reject form and tradition limit their poetic arsenal. He is right about many of the questions of technique that poets argue about; however the question the book only approaches gently is not 'how poetry?', but 'why poetry?' Maxwell provides great guidance as to *how* one could make better poems, but perhaps to others it might be less self-evident as to why one *should* make better poems. What is it that approaching language through poetry can achieve? Arguments about form and tradition have their place and are vitally instructive but perhaps the classroom, comfortably institutionalised and safe from the taxpayers, does in fact need to make a case as to why poetry is more valuable than crisps.

The Gorillas Died

Gee Williams

Liam Murray Bell & Gavin Goodwin (eds.), *Writing Urban Space*
Zero, 167pp ISBN 9781780992549 £11.99

As always come the warnings from those in the know - those with passports stamped by mere survival and their papers, probably forged, made out in local names. The good neighbourhood to buy into if you can is - vague gesture - round about the ... they name a 'famous landmark' you've never heard of. The street to keep moving on, head up ... well you can see the entrance down there on the left amongst the dereliction. All good and bad advice. All necessary seasoning for someone who lives in her current piece of fiction and that means I'm in Rhyl-of-the-mind, at present, 'Britain's first shanty town' according to The Times. And a lot of the last few years I've been *really* in Rhyl, cruising the empty arcades, reading the boarded up shop fronts and talking to the guy stealing beach sand, that's right, sand in Tesco bagfuls till he'd enough to finish concreting his floor. And, by offering to act as his lookout, getting it wrong. Scaring him off.

Writing Urban Space is a volume of essays exploring the relationship between creative writing and the built environment. Here a disparate twelve – as the editors admit the 'term writer is a flexible concept here' – of essayists, fictioneers, performance poets and critics try to navigate without scaring their subjects off.

But what if the cul-de-sac you find yourself in has a mirrored barricade? Liam Murray Bell's attempted director's cut of his Belfast novel *So It Is* with extra murals (sic) is too easy on a visual form specious and degraded at its birth and over indulged with

notice ever since. Of course Channel 4 is going to use an image of gable-high posturing gunmen as shorthand for we're in Ulster (at the opening of *Come Dine With Me*) 'even though,' Bell explains, 'such images obviously bear no relevance to the show's content.' Y'think? He does concede 'it is debateable whether these symbols of conflict truly represent the two traditions of Northern Ireland,' but remains trapped in his looking-glass world. Step through and what's more debateable is just how well *Come Dine With Me* represents the Northern Irish tradition. Better, I would like to make a case for.

The map certainly is not the territory. Too fervent a concentration on the map sends visitors crashing- and unlike Popper, some of the chosen twelve write in prose of variable lucidness. But patience and determination can reward effort. Good rough guides include Peter Bearer's assault on corporate messaging by street art, 'uncooling brands,' that made me wish I'd been in Oxford in the 1980s. Also (my favourite) the conversion of four undistinguished Copenhagen roads lined with brutalist structures into linear poems, installed by a Jan Hatt-Olsen with Blakean verve.

The urban environment, intact, damaged, ruined, aged or distorted, is fast becoming the human predicament, its anthem, 'Bob said, *We have to get out of here*' (Elizabeth Jane Burnett's 'Finding the Words'). A chilling look at how and why and so what? is David's Ashford's 'Postcards from the House of Light.' The first five pages, a description of Berthold Lubetkin's house of the title –built not for people but a pair of tormented gorillas to be exhibited by London Zoo – and the ruinous effect on those forced to inhabit it is well worth the curiously old-fashioned ten-page narrative onto which it is spliced. And his quotation from Peder Anker, 'It was thus of revolutionary importance to display thriving animals in an unnatural setting as if to prove that humans too could prosper in a new environment,' is the only preface this collection needs.

Oh and as postscript, the gorillas died - quickly, slowly, nastily.

Loser Romanticism

David Winters

Peter Sloterdijk, *The Art of Philosophy: Wisdom as a Practice*
Columbia University Press, 120pp ISBN 9780231158718 £13.95

Philosophy, as Pierre Hadot once put it, is perhaps less a body of knowledge than a 'way of life.' If this is so, it follows that philosophers shouldn't be overly idealistic about their ideas. Such ideas are embedded not only in broad social contexts, but in philosophers' own self-understandings; in their acts of self-fashioning. And to the extent that this existential dimension remains largely repressed or unthematised, the discipline stands in a state of reflexive deficit. In this respect, what we require is a materialist theory of philosophy: a robust redescription of contemplation as, first and foremost, an embodied practice.

For Peter Sloterdijk, such practices properly belong to the sphere of 'anthropotechnics.' In his bestselling book *You Must Change Your Life* (Polity, 2012), Sloterdijk defines this terrain as 'the tableau of human "work on oneself"... a region that can be referred to with such categories as education, etiquette, custom, habit formation, training and exercise.' *The Art of Philosophy* brings precisely this perspective to bear on the stances and attitudes that underwrite science, scholarship, and what we unthinkingly call 'the life of the mind.' Seen in this light, such a life looks newly unusual:

> *'If the theoretical attitude is to be a matter of practice, then the cardinal exercise would be a withdrawal exercise. It would be an exercise in not-taking-up-a-position, an attempt at the art of suspending participation in life in the midst of life.'*

The life of the mind is a way of life that withdraws from life. This is the central thesis of Sloterdijk's striking book, whose title in German is the more apposite *Scheintod im Denken* — 'Suspended Animation in Thought.' Sloterdijk starts with Plato's account of Socrates, for whom philosophical thought took the form of 'a trance or obsessive daydream.' In short, Socrates was sometimes literally 'lost in thought,' gripped by a kind of 'artificial autism' — an ascetic secession from social life into the realm of ideas. To think, for Socrates, was to be dead to the world. Accordingly, Sloterdijk relocates the root of 'the ancient European culture of rationality' in 'the idea that the thinking person is a kind of dead person on holiday.'

This statement's irreverence is instructive. By his own admission, Sloterdijk is intentionally 'hyperbolic,' and hardly a slave to scholarly standards. Like several of his shorter texts, *The Art of Philosophy* started life as a lecture: a form in which intellectual substance isn't straightforwardly separable from rhetorical strategy. It's unclear whether Sloterdijk's writing could itself be called 'philosophy,' but perhaps this accounts for its polemical power. His style circumvents any single disciplinary discourse. Instead, it comes from a place where such canons can be creatively combined, ironised, or iconoclastically attacked.

In consequence, Sloterdijk quite often brings a bracing anti-academicism to his arguments. *The Art of Philosophy* is no exception. Taking up an old idea of Nietzsche's, the book portrays the founding of Plato's Academy as a retreat from a failing Athenian political culture: 'a reaction to the collapse of the *polis*.' On this reading, philosophical or theoretical life — the *bios theoretikós* — arose in response to the death throes of democracy. Since then, academe has always been about 'shutting out the world,' for better or worse. And as for the 'love of wisdom,' says Sloterdijk, 'it was the first and purest form of loser romanticism, reinterpreting a defeat as a victory on another field.'

Later, this rubric of 'loser romanticism,' itself reminiscent of

Nietzsche's notion of *ressentiment,* inspires an incisive foray into the psychology of theory. For Sloterdijk, the people most prone to take flight into theory are those 'who seem lost in the world.' But by looking closely at this loss, this 'low-level alienation,' we can cast theory's unworldly ideals under suspicion. So, Sloterdijk calls for a critical genealogy of the 'theorist' as a character type:

> *'What if the much-lauded theoretical virtues really derive from secret weaknesses? What if they're based on a questionable compensation for stubborn defects, or even on the morbid inability to face the facts of life without embellishment and evasion? Does homo theoreticus really come from such a good background as he has assured us from his earliest days? Or is he actually a bastard trying to impress us with fake titles?'*

Surely some of us will see ourselves — and laugh at ourselves — in what Sloterdijk calls his 'portrait of the theoretician as a young man.' Nonetheless, theoretical life needn't always be damaged life. As Sloterdijk explains, 'a definitive exposure of theory as "nothing but" compensation for something better ... cannot succeed.' Crucially then, his approach isn't crudely reductive. Far from being a one-sided critique, the book becomes ever more flexibly essayistic, mapping the philosophical mindset in all its ambiguous 'happiness and misery.'

The Art of Philosophy ends in the present era, in which 'episte-mological modernism' has demystified many of the 'exalted fictions of disinterested reason.' From Marx to Sartre to Bourdieu, modernity has at least partly re-coupled cognition to concrete customs, promising a 'liquidation of the ancient European subject of theory.' But for all this, traces of 'suspended animation' still survive, as do 'distant glimpses' of Socrates' sacred absences of mind. And so they should, resolves Sloterdijk. Philosophy can't be conclusively purged of its ascetic inheri-tance. But perhaps we can conceive of a world in which

philosophy's past is repurposed; put in pursuit of a way of life that is 'neither merely active nor merely contemplative' — wisdom as a new kind of practice.

Follow the Money

Robert Barry

Jonathan Sterne, *MP3: The Meaning of a Format*
Duke University Press, 360pp ISBN 9780822352877 £16.99

In 1874, Alexander Graham Bell and Dr Clarence Blake, an otologist from Boston, devised a peculiar contraption they called the 'ear phonautograph'. One of the very first devices capable of transforming sound into something else (in this case, a graphic mark), the ear phonautograph was constructed using the excised tympanic mechanism from an actual human ear obtained from the Harvard medical school. Not just the forerunner to the telephone invented by Bell two years later, the tympanic function extracted from the human middle ear which it operationalised - i.e. the beating of the tympanic bones against the ear drum - would provide the prototype for the transducers within all sound media to this day, from microphones to phonographs to loudspeakers.

Fifty-five years later, and 260 miles down the coast at Princeton, two psychologists created another strange bio-mechanical device. Removing part of the skull and most of the brain of a live cat, Ernest Glen Wever and Charles W Bray attached electrodes to the creature's right auditory nerve and one other part of its body. These were then hooked up to a telephone receiver by way of a valve amplifier in a soundproof room. Positioning one researcher at the receiver, the other spoke into the cat's ear. To their mutual astonishment, they found they were capable of communicating through this *cat telephone* 'with great fidelity'.

In between these two curious experiments, a fundamental shift had occurred in the science of acoustics which would have

profound consequences for another decerebrated cat wired permanently into a machine: the headphone-wearing 'kitty head' whose image would provide a logo for the peer-to-peer downloading service, Napster. For the extraordinary mobility of the MP3 presupposed a whole history of compression based upon a psychology of perception. Acoustics had moved from a physiology of dead subjects, centred around the bones and diaphragm of the middle ear, to a psychoacoustics of the living, centred upon the inner ear and auditory nerve.

Jonathan Sterne's *MP3* traces the sonic genealogy of the much-maligned format from its roots in AT&T's drive to maximise profits by squeezing as many calls as possible into a given phone line, eking out the implications of each stage along the way. A sequel of sorts to 2003's *The Audible Past*, which offered a history of listening between the stethoscope and the gramophone; *MP3* brings the story up to the present day, taking in information theory, architectural acoustics, and the vocoder along the way, before finally settling down to the development of the MPEG standard itself and some of the more philosophical implications thrown up by it.

The MP3, Sterne claims, is a 'container format', analogous with the shipping containers which permanently criss-cross the world's navigable waters. "Just as a shipping container can hold anything smaller than its interior space, an MP3 file can hold any recorded or transmitted sound." And as anyone who recalls season two of *The Wire* will tell you, the shipping container is as much a vector of organised crime as unfettered global capitalism - and tends to blur the distinction between the two.

Likewise, the MP3. Sterne argues strongly against the usual perception of bootlegging 'pirates' and the music industry inhabiting, as it were, two distinct boats. 'Follow the money,' as Dectective Lester Freamon used to say, and you'll find the industry fully embedded in the MP3's circuits of exchange through profits dervied from blank media, hardware and

connection charges. Sterne brings up the instructive example of Sony Electronics releasing a CD player that would play MP3 CDs, even as Sony Music was engaged in a years-long lawsuit with Napster.

The present book developed out of a short essay for *New Media & Society* in 2006 in which Sterne rather damns the format for putting the human body 'on a sonic austerity program. It decides for its listeners what they need to hear and gives them only that. Listeners' bodies, brains and ears then contribute a kind of surplus activity (if not quite labour) to make the system run ... it represents a liberation of just-in-time sound production, where systems give listeners less and ask their bodies to do more of the work. In the meantime, however, Sterne admits to have "changed his mind on lots of things since then.' If there is a problem, then, with the book it is perhaps in its author's tendency to equivocate; to hedge his bets behind a facade of academic objectivity.

Which is not to say the perceptual coders and psycho-acousticians at Fraunhofer, developers of the MP3, are completely let off the hook. One telling anecdote speaks volumes about the interplay of gender and power behind this supposedly most universal of formats. Part of the mythology of MP3 history is the role played by Suzanne Vega's track 'Tom's Diner'. The story goes that the fidelity of the format is the result of engineer Karlheinz Brandenburg repeatedly playing the song through his codec, endlessly refining until it had perfectly captured the warmth of Vega's voice.

So it happened that in 2007, the singer was invited to the Fraunhofer Institute - billed by the latter's PR team as a visit from the 'mother of MP3', much to Vega's horror at the implication that she was about to meet the format's various fathers. Before a gathering of press, a panel of engineers played first the distorted version Brandenburg had been so struck by, and finally the 'perfect' MP3 copy. Sterne quotes from Vega's own account.

'See,' one man said. 'Now the MP3 recreates it perfectly. Exactly the same!'

'Actually, to my ears it sounds like there is a little more high end in the MP3 version? The MP3 doesn't sound as warm as the original, maybe a tiny bit of bottom end is lost?' I suggested.

The man looked shocked. 'No, Miss Vega. It is exactly the same.'

'Everybody knows that an MP3 compresses the sound and therefore loses some of the warmth,' I persisted. "That's why some people collect vinyl . . . " I suddenly caught myself, realizing who I was speaking to in front of a roomful of German media.

'No, Miss Vega. Consider the Black Box theory!'

I stared at him.

'The Black Box theory states that what goes into the Black Box remains unchanged! Whatever goes in comes out the same way! Nothing is left behind and nothing is added!'

I decided at this point it was wiser to back down.

'I see. OK. I didn't realise.'

A better example of the phenomenon defined by author and journalist, Rebecca Solnit as 'mansplaining' would be difficult to come by.

An Arbitrary Encyclopaedia

David Anderson

Jonathan Meades, *Museum Without Walls*
Unbound, 352pp ISBN 9781908717184 £20.00

Passing some time before a mis-scheduled appointment at St Bartholomew's hospital in Smithfield, I visited the plaque hanging in the attached museum. 'You have been in Afghanistan, I perceive', runs the bronze-embossed motto, commemorating the first words spoken on this site over a century ago by the consulting detective Sherlock Holmes, to his soon-to-be chronicler Dr John Watson MD. Enquiries reveal the plaque's position to be misleading: the meeting took place not here but up some stairs and around a corner, in an office now known as the Sherlock Holmes Room. A former hospital employee of an exegetical persuasion hung it there, whence it was removed to a more convenient location by virtue of the sheer volume of pilgrims it receives.

The absurdity of this practice would surely appeal to Jonathan Meades. In *Museum Without Walls*, an assortment of 'lectures, essays, polemics, squibs and telly scripts', Meades reaffirms his dictum that his work is 'not about places, but about ideas about places' - the interlay of fact and fiction through which our environment is filtered by the imagination. Meades' productions, both textual and televisual, are 'expressions of an incurable topophilia', often made after 'having paid only the most cursory visit to the places in question.'

A critical maverick, Meades is like a Jeremy Clarkson of the chattering classes, or, in his trademark black shades and suit, a peculiar blend of Nikolaus Pevsner and John Cooper Clarke. Verbose, precise, acerbic, daft; his idiosyncratic merger of the

trivial and the profound sees him cut from a different cloth to most other commentators. Just as, presumably, the cloth of his suits, which expand and contract to improbable degrees across a 20-year span, whereby his wildly fluctuating body weight came as a result of an overindulgent stint as restaurant critic for The Times.

Meades' work is peppered with wry jibes at religion, 'a low-grade form of learnt imagination. [An imagination where someone else has done the imagining for you.] But imagination nonetheless.' Such humanist virulence is tempered and explained by his approach to the built environment, gauged with most clarity in a script not included here, the autobiographical *Father to the Man*: 'My antipathy to the God malarkey, and to such half-wittedly frivolous notions as intelligent design, may have their roots in this preoccupation with what was obviously made Most of what we see around us in England is creation. Our forebears' creation. It's their intelligent design. Rivers and fields no more just happen than do buildings. They're industrial sites.'

In this book he refers frequently to the 'floating meadows' of his native Wiltshire, facilitated by man-made waterways called 'leets'. The deployment of this obscure and elegant term is symptomatic of the exploitative pleasure Meades takes in language: his aside that 'God is famously over-housed' comes via the etymology of the word 'dome', just as Rayner Banham's coinage of 'brutalism' is clarified as a bilingual pun on *'beton brut'*. Few other places will you hear 'sybaritic', 'bombastic' and 'bogus' used with quite such alacrity, but Meades sees himself as taking a scalpel to the 'esperantist pidgin' of architectural discourse, 'self-referential, inelegant, obfuscatingly exclusive'. His defence of Ian Nairn is mounted on the basis of 'a long tradition of journalists who do not write journalese', and Meades figures himself in the same line as Nairn; 'an anarchic pedagogue who lurched from drayman's mandarin to saloon-bar vernacular' and who 'was loyal only to his own sensibility, to his own intellect.'

This intellect is freewheeling and 'like nearly all writers, but unlike nearly all architects,' autodidactic. 'Starchitects' like Zaha Hadid are the counterpoint, bred on the 'lingua franca of intercontinental architecture' whose patina is reflected in the bizarre situation wherein Zaha 'still does not have a single building to her name in London despite having lived and worked here for three and a half decades' (though she does now, a Stirling Prize winner among them), and where Norman Foster will helicopter in to visit his creations like a descending deity.

In 'On the Brandwagon' this self-perpetuating architect-speak is linked to the insight that 'Regenerative cities replicate each other's buildings', a practice which 'is insulting - it omits all that is specific to a place.' Meades reserves the right to revel in non-placeness ('Canary Wharf proclaims the briefness of the history attached to it ... it might be anywhere ... This dislocation is precisely what makes it so satisfying.') but he is more usually a disciple of 'places' in a heterogeneous, unorthodox sense. In condemnation of Blairite 'quasi-modernism' - which wants only 'to be instantly and arrestingly memorable, and to be extraordinarily camera friendly' - he stands shoulder-to-shoulder with the 'conservative Marxist' Owen Hatherley's criticisms of the 'pseudo-modernism' of 1990s Private Finance Initiative schemes, and the cult of the building-as-icon.

At one point in *Museum Without Walls* Meades does mention Hatherley, praising the 'suppleness and fluidity' of his prose. What the latter has called Britain's 'new ruins' are also Meades' focus: decay, residue, and the 'habitually ignored'. His understanding of England's suburban edgelands is persuasive, and parallels Patrick Keiller's 1994 observation that 'London is a city under siege from a suburban government.' 'The history of English urbanism', Meades writes, 'is equally the history of *sub*urbanism Mistrust of urbanism and of cities themselves ... is very deeply embedded in the English psyche.' He is at pains to point out that 'of the western European countries it is only in

England that the epithet *inner city* is synonymous with crime, destitution, social deprivation. Why? Because it is only in England that the people who run cities and who generate the wealth of cities, live in exurban dormitories and so have no *personal* stake in those cities.'

Glasgow's centripetally oriented suburbs are presented as a singular antidote, but Meades also highlights an urban/suburban shift more familiar to southerners, remarking that 'within a few decades inner-city Britain will come to resemble inner-city Europe'. Long-time resident of France, he seems tentatively enthusiastic about this, whilst remarking the hallucinatory 'impression of a virtual European city towards which London is unwillingly shoved', the danger of sanitised pseudo-public spaces and 'intravenous cappuccino'. Perhaps he has more to worry about: the supermodernity of monolithic structures pinned to euro-style 'quarters' threatens the type of criticism practiced by Meades (and Nairn, and Pevsner), a practice occasioned by the very multifariousness and unplanned variega-tions of England's aesthetic, its lack of stylistic consistency.

Privileging the oblique angle and revelling in unwitting cultural overlaps, Meades lists some seminal works by foreign writers and filmmakers in Britain and notes that the land they depict is 'like a photograph which has been reversed - which is possibly the way we see places we know in dreams, before they are corrected by the brain.' His example of Michel Butor's sponge cake in *L'Emploi du Temps* (2001) recalls WG Sebald's fascination with the 'Teas Maid' supplied by his landlady in *The Emigrants* (Vito von Eichborn, 1992), and it is in this spirit that 'The character of a place is to be found in the ordinary - the apparently ordinary.' Like the absent cosmopolitan voice of Chris Marker's 1983 film Sans Soleil ('I've been around the world several times, and now only banality still interests me'), for Meades 'the banal is a thing of joy', and his surrealist proclivities remind us of Jean Painlevé's liquid crystals when he adds that, 'Everything is

fantastical if you look at it long enough'.

Meades writes that 'although it may be foolish to judge by appearances it is even more foolish not to judge by them', and though his stated intent might be to 'peel off the drab grey overcoat of preconception, to reveal the lime green posing pouch of reality beneath', his method is responsive to Wilde's aphorism that 'the true mystery of the world is the visible'. These preoccupations bring with them the ideals of an aesthete. 'We don't go to Dorset in search of Hardy's landscape and villages, or if we do we won't find them - because they exist only in the compact which the writer makes with his audience.' And yet it is precisely this interaction that underpins the words embossed in capitals on the book's cover: THERE IS NO SUCH THING AS A BORING PLACE. Visiting monuments might be absurd, but Meades' films benefit from necessarily having to show us something - to the same degree that the book suffers by its lack of images. One finds a singular hint of visual interest in the unassuming occurrence of the Mistral typeface, the creator of which, Roger Excoffon, is enchantingly hymned in the first episode of the France trilogy (script included). But without the films the texts feel incomplete, and this fact (alongside a clumsily repetitious structure) hampers the collection, creating a book that is essentially a frustratingly disorganised rag-bag of Meades' thought which lacks the economical lucidity that he achieves so readily on screen.

Will Poetry Really Save Us?

Daniel Hartley

Franco 'Bifo' Berardi, *The Uprising: On Poetry and Finance*
MIT Press, 160pp ISBN 9781584351122 £9.95

Let us imagine three rooms, each one sealed off from the others and furnished with a single desk, a keyboard and a computer screen. In the first room sit Deleuze and Guattari, in the second TS Eliot, and in the third FR Leavis. The computer system into which they type is designed to cut and paste extracts from all four thinkers, to superimpose some passages on others, and to create an overall palimpsest of their work. The final product, I claim, would be something akin to Franco 'Bifo' Berardi's new book, *The Uprising: On Poetry and Finance*.

From Deleuze and Guattari he takes a jargon at times so alienating that his call for poetry as a form of resistance against 'techno-linguistic' abstraction becomes an ironic gesture in its own right. From Eliot (unknowingly, one presumes) he takes an updated version of the 'dissociation of sensibility' thesis. For Eliot, some time in the 17th century – conveniently around the time of the English Revolution – thought was devastatingly uncoupled from feeling. For Berardi, by contrast, the autonomisation of the signifier (or, the demise of the referent), first developed in symbolist poetry, was a mere precursor to the financialisation of capitalism whereby sensuous physical commodities in the real world were no longer relevant to the production of value. Finally, from Leavis (again unknowingly), he inherits that glorious contradiction between an image of a world so ubiquitously fallen it would take a miracle to change anything whatsoever, along with the faintly ridiculous suggestion that poetry (or, in Leavis' case, 'close reading') will nonetheless save us all.

I am, of course, being provocative. The book is not nearly as dubious as that description would imply. But my point is to suggest that Berardi's diagnosis of our current situation and his consequent strategic proposals, if taken as *theory*, are not nearly as politically radical as the bureaucratic-revolutionary style would have us believe. His main aim, he tells us, is 'to develop the theoretical suggestions of Christian Marazzi, Paolo Virno, and Maurizio Lazzarato in an unusual direction.' These three men are all inheritors of the Italian *Operaismo* (or 'workerism') tradition, initially developed in Italy throughout the 1960s and 70s. A disparate tradition of many lines of thought, in one way or another it was united around the idea that capitalism was undergoing or had undergone a fundamental mutation. Whereas in previous forms of capitalism the factory and its modes of organisation, production and value-extraction were relatively separate from society at large, in the new post-Fordist world, society itself had become subsumed in its entirety under the logic of the factory. As Mario Tronti wrote at the time, '[a]t the highest level of capitalist development, the social relation becomes a *moment* of the relation of production.' The upshot of this process was that areas of social life previously presumed to be external to capitalist valorisation processes – language, affect, thought, desire, subjectivity – were now being put to work in their own right. It is in this context – one which Berardi himself nowhere clearly delineates – that Berardi's book must be located:

> *'These thinkers have conceptualized the relation between language and the economy, and described the subsumption and the subjugation of the biopolitical sphere of affection and language to financial capitalism. I am looking for a way to subvert this subjugation, and I try to do that from the unusual perspectives of poetry and sensibility.'*

How does Berardi go about this? First, we must understand his unique variation on the general workerist theme. Language, Berardi argues, has become disembodied: 'signs fall under the domination of finance when the financial function (the accumulation of value through semiotic circulation) cancels the instinctual side of enunciation.' In other words, 'signs produce signs without any longer passing through the flesh.' The structuring argument of the book is that, just as symbolist poetry engaged in experimentation 'with the separation of the linguistic signifier from its denotational and referential function, so financial capitalism, after internalizing linguistic potencies, has separated the monetary signifier from its function of denotation and reference to physical goods.' 'Language' has become automatised: it speaks of itself to itself without the corporeal intervention of a real speaker.

This automation then 'sucks down' and 'dissolves ... collective semiotic activity.' Consequently, this has produced a paradigm shift in the nature of human sociality as such. Once a 'conjunction' of affective bodies (conjunction here means a series of interactive encounters or 'becomings-other' between two or more agents), it has now become a realm of 'connection' in which each individual remains unchanged by communal (non-)interaction, a mere appendage to mechanical functionality (very much like what Sartre called 'seriality'). This, in turn, has generated the demise of social solidarity. The only way to overcome these problems is via poetry and voice: poetry, 'the excess of sensuousness', can '[reactivate] the emotional body, and therefore [reactivate] social solidarity' whilst voice 'cannot be reduced to the operational function of language.' Poetry will reanimate our deadened sensibilities and resurrect our flesh; in doing so, it will rehabilitate social solidarity.

To say there are problems with this argument is an understatement. For a start, it implies the existence of a homogenous and ubiquitous linguistic situation, as if the language of a

Brazilian shanty town, a Sudanese village and a Parisian five-star restaurant were structurally and intensively identical. In other words, Berardi has no sense of the unevenness of linguistic development (nor – at least in this work - of capitalist development more generally). Next, there is the even bigger problem of his explanation of the causes of our current plight. Did symbolist poetry somehow *cause* financial deregulation? Or is the relation merely one of homology? If the latter, why the constant stress on their mutual imbrication? Did the digitalisation of the communication process (even presuming it to be ubiquitous – which it is not) really *cause* the shift from conjunctive sociality to connective sociality? And does this latter form of sociality really constitute the *totality* of social relations? Without a clear conception of cause and effect – even if we were to subscribe to some version of 'immanent causality' – what hope do we have of producing effective political strategies?

A third problem is Berardi's very conception of language itself. One minute it seems to denote verbal language, but the next it seems to refer to financial statistics, digital codes and so on. Surely, some internal distinctions within the field of semiotics are the prerequisite of a more exact analysis of the effects of financialisation on human communication. Moreover, that he nowhere takes into account the basic Derridean insight - that without the supplement of abstraction there would be no 'concrete' language in the first place - is surely a problematic oversight in a work of this nature. Finally, there is the problem of what 'poetry' actually is. If poetry 'is the language of nonexchangeability', one whose hermeneutical ambiguity escapes the mechanical functionality of digital networks, why has Berardi spent half the book telling us that *symbolist* poetry is a constitutive factor of the very problem he wants to solve? *Which* poetry is the one that will save us? Conceptual poetry, L=A=N=G=U=A=G=E poetry, beat poetry, romantic poetry, neo-classical poetry? We are never told.

This is why Berardi's book should not be read as a theoretical analysis or practical guide. Instead, it should be read as a new type of writing: one that combines the sheer libidinal excitement of French poststructuralist thought with the political passion of a seasoned radical. The book is full of wonderful vignettes on current social malaises (especially those of the Facebook generation), and is packed with sequences of acute political analysis (on, for example, the impending threat of ethnic civil war if European financial dictatorship continues). But these never add up to an internally coherent theory. Ultimately, then, a radical political strategy which *ignores* the recent shifts in social experience to which the abstract lyricism of this book is testament will certainly prove insufficient; on the other hand, a strategy which takes it as its guide will be doomed to failure.

Are You An Idiot?

Stuart Walton

Neal Curtis, *Idiotism: Capitalism and the Privatisation of Life*
Pluto, 184pp ISBN 9780745331553 £21.99

One of global capitalism's subtlest achievements has been to convince its client populations throughout the developed and developing worlds that it has made available to them a potentially limitless field of social, economic and cultural opportunity. In opposition to the monolithic state communism of the former eastern bloc, but also against the misguided strictures of social democracy in its self-defeating obsession with welfarism and redistributive taxation, the global market frees each individual subject to extend itself to the full elastic limit of its self-realisation. In this, it congratulates itself only half-ironically on having carried out the Marxist desideratum that the free development of each is the condition for the free development of all, releasing postmodern subjectivity into a dynamic field of choices, potentialities and re-fashionings, according to the tenor of the individual's unbounded desire.

The reality has been somewhat at odds with the ideology. Deregulation of the markets accompanied the financialisation of the world economy set in motion in the late 1970s, resulting in the enslavement of whole populations to personal and national debt. Monetarism compensated its victims for their depressed wages with the offer of a credit boom, and eventually oversaw the outsourcing of labour to markets where it came more cheaply and could be bought with fewer institutional safeguards. Forms of political organisation have withered under the wholesale commissioning-out of policy decisions to financial consultants, and the concomitant transformation of the electoral apparatus

into a gigantic PR exercise. Meanwhile, the individuals who might once have constituted a collective resistance to the prevailing system are frozen in atomised isolation at their computer keyboards, bickering with other disembodied entities on Facebook or racking up scores on Black Ops.

In a usage plangent with rhetorical force, Neal Curtis diagnoses this global condition as 'idiotism', referring the term back to its productively ambiguous Greek etymology. *Idios* means 'private', in the juridical sense that denotes private belongings or personal opinions, but also in the restrictive sense that an *idiotes* was someone whose lack of special knowledge or expertise disqualified him or her from participation in the public realm of the *polis*. These twin valences inform the lives of capitalism's subjects in the age of global finance and electronic communication. The supreme paradox of the rule of a financial oligarchy that, despite its implosion in 2008, has been saved from obsolescence by enforced public subvention, is that it is awarded its hegemonic role under the official principle of decentralisation, of devolving economic choice on the individual consumer. And yet it is only as a collective economic agent that the mass of society is enlisted to confer its blessing, at gunpoint, on the predominance of globalised exchange. 'Idiotism,' Curtis writes, 'remains entirely parasitic on a host it claims does not exist.'

Successive chapters on the economic and political mechanisms of idiot capitalism rehearse the structures and institutional effects of the present dispensation, all the way to the foul requirement for candidates for even the most menial of jobs to pretend to identify with them spiritually, their passion for toilet-cleaning so intense that they are prepared to let potential employers audit the unadulterated contents of their bloodstreams to prove their eligibility.

It's in a chapter on 'Idiotism and Culture', though, that Curtis's theory gains its greatest traction. Here is something like an outline of what the later Frankfurt School would have made of

the electronic era. The universal 'bustle' that Theodor Adorno derided in the 1960s has become the chatter of instant-access information, the speed of which, as Curtis poignantly remarks, creates the sense that we are never quite keeping up with all there is to know. Participation in localised forms of political activity takes the form of clicking 'Yes' to an online petition to stop the badgers being gassed, before one logs on to the internet dating site in hope of replies. The notorious cookies that support what the internet knows, in a grotesque phrase, as 'behavioural advertising' watch carefully to see where our tapping fingers go, so that commercial organisations can broadcast their messages to us more pervasively, ensuring that we remain fed on an invariant regimen of the self-same. Connecting to celebrities on Twitter has enabled participants to feel, albeit in a largely one-sided sense, that they have somehow penetrated the inner sanctum, for all that the celebrities themselves are 'now celebrated for nothing beyond the immediate fact of having made themselves more visible than other people'.

What is largely missing from this otherwise richly suggestive account is a more fully expounded dialectical investigation of the relations between the public and private realms the argument delineates. In accepting that what the Frankfurt theorists liked to call the 'totally administered society' remains more securely in place than ever, despite the 2008 calamity, the argument overlooks the less obvious mediating processes that take place between the public and the private. In the cultural realm, it remains true, as Curtis argues, that acts such as buying fair-trade chocolates online stand for the commodification of ethical awareness, and yet there are other ways in which electronic contact has enabled the elaboration of a sense of self even within the constricting bounds of the global orthodoxy. A Facebook friend, Curtis reports, is upbraided for treating his own page as an extension of his therapist's office, but why wouldn't that be potentially more constructive than using it solely to put up links

to Youtube videos or remember each other's birthdays? It may well be that what present conditions have brought about is a privatisation of the public, but might there not be some subversive potential in a publicisation of the private, a phenomenon that, if anything, Curtis is inclined to deplore as the degrading of the public to nothing more dignified than 'exposure'.

Then, too, it has always been possible to construe the private not just as a retreat into solipsism, but instead as a place of resort from a contaminated public realm. Privacy doesn't have to be equated axiomatically with the solitary. There are ways of being private together, in the forms of underground cellular political activity in conditions of dire repression, of *samizdat* literature, of love-relationships that defy a proscriptive orthodoxy, of the use of banned intoxicants. From these forms of dissident privacy have often emerged habits of consciousness that defy the status quo more comprehensively than the public phenomena of demonstrations and sit-ins. Granted, there is no 'outside of capitalism', as Alain Badiou puts it, but there are interstitial spaces within it where its writ doesn't run. It is at least possible, although a desperate wager to be sure, that forms of resistance may continue to arise from something like a collective of singularities, rather than the old-fashioned mobilisations that capitalism has always been adept at assimilating, where it hasn't felt the need to crush them.

If these traces represent too faint a glow of rebellious ardour, amounting to barely more than the mental agility that was the only vestige of Marxism his enemies saw in the later thought of Adorno, the only alternative is the old recourse to collective strategy. For this, nothing other than the classic continuum Slavoj Žižek has recently outlined will suffice. A protest must evolve into a movement, and a movement into a party with a leader, to promulgate a fully elaborated programme. Curtis is more or less allergic to any such talk, however, pointing out with the aid of

Martin Heidegger, of all the improbable metaphysical allies, that all such enterprises tend to solidify into dogmatic rigidity. What seems preferable is politics as a continuous search for a permanently elusive truth, rather than one predicated on 'any ultimate ground or foundation'. But then why look for truth particularly, as opposed to, say, happiness or fun? Politics should indeed be a self-reflective method, rather than a steady state. Bureaucratic degeneration did indeed ruin the 20th century's attempts at Marxism on the national scale, but political practice as a contentless pursuit of chimerical truth has produced nothing of any greater impact than the Occupy episode, a purely formal representation of protest, complete with nuisance value and trick-or-treat comedy masks, but tongue-tied when it came to deciding what it wanted to achieve, and therefore how it would know when it had achieved it. Might it be that the tent-encampments in the parks and on cathedral greens were precisely idiotism's version of dissenting politics?

zero
books

Contemporary culture has eliminated both the concept of the public and the figure of the intellectual. Former public spaces – both physical and cultural – are now either derelict or colonized by advertising. A cretinous anti-intellectualism presides, cheerled by expensively educated hacks in the pay of multinational corporations who reassure their bored readers that there is no need to rouse themselves from their interpassive stupor. The informal censorship internalized and propagated by the cultural workers of late capitalism generates a banal conformity that the propaganda chiefs of Stalinism could only ever have dreamt of imposing. Zer0 Books knows that another kind of discourse – intellectual without being academic, popular without being populist – is not only possible: it is already flourishing, in the regions beyond the striplit malls of so-called mass media and the neurotically bureaucratic halls of the academy. Zer0 is committed to the idea of publishing as a making public of the intellectual. It is convinced that in the unthinking, blandly consensual culture in which we live, critical and engaged theoretical reflection is more important than ever before.